Brunel and the Art of Invention

For my grandfathers Harold Septime Bourgeois and Ronald Jackson Richmond

A pioneering engineer and industrialist, Isambard Kingdom Brunel was also an imaginative artist and collector. He is typical of the ways in which art, science and industry have worked together to achieve creative invention, encouraging new ways of thinking and seeing from the Victorian age to the Brunels of the future.

This book explores the art of invention through four themes: Inventing Britain; Travel and Transport; The Art of Work and Brunel as Artistic Engineer.

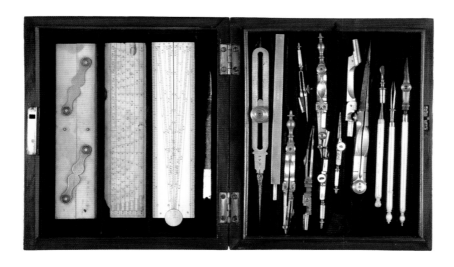

Isambard Kingdom Brunel's instrument box

Brunel and the Art of Invention

Claire O'Mahony

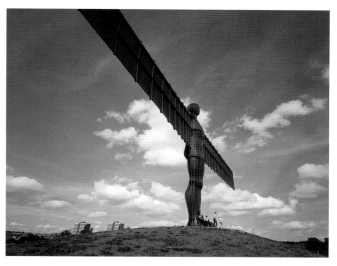

Angel of the North, Antony Gormley

Sansom & Company

Acknowledgements

Exhibitions and their catalogues are always a joyously collective enterprise; *Brunel and the Art of Invention* has been the work of many hands. First and foremost, any acknowledgements must begin by celebrating the tireless energy and vision of Mel and Andrew Kelly, who forged 'Brunel 200' and its wondrous variety of artistic, scientific and entrepreneurial initiatives, and Ruth Sidgwick, their enthusiastic project manager. This book is particularly indebted to Mel who brought together the many and excellent illustrations, no matter how arcane and tardy my requests were! John Sansom's knowledgeable and gentle editing reflects what a generous and inspirational publisher he is. My thanks to Clara Sansom for her careful reading and editing and to Stephen Morris for his elegant design. The staff of many Bristol institutions have helped to bring the project to fruition: Michael Richardson and Hannah Lowery at the University of Bristol Arts and Social Sciences Library Special Collections; Chris Redford from the Industrial Museum; Alice Rymill from Blaise Castle; Julia Carver, Rebecca Ellison, Frances Hinchcliffe, Kevin Locke, Claire Royal, Sandra Stancliffe, Sheena Stoddard, and Phil Walker from Bristol's City Museums and Art Gallery; Frances Bell, Kate Rambridge and Matthew Tanner from the ss *Great Britain*. The staff of all the institutions and private individuals lending works to the exhibition have played a vital part in making this feast for the eyes and mind; I am particularly grateful to Ulrike Schulte and Jenny Grant at the Imperial War Museum; Dr Mary Cowling of the Royal Holloway and Queen Mary College; Richard Green, Matthew Green, Rachel Boyd and Peter Brady of the Richard Green Gallery; Ruth Hibbard and Rebecca Wallace at the Victoria and Albert Museum; Marc Bowles and Antonia Charlton at the Museum of London; David McNeff at the National Portrait Gallery; Katherine Clements at the Tate; Simon Lake at the Leicester City Museum, Nathalie Morena at the Centre Nationale de Cinematographie and to Adrian Andrews, Julia Elton and Christopher Grindley for their sage advice. On a more personal note, I am grateful to my parents for surrounding me with ships and Victorian novels from an impressionable age, but most of all to my husband Mike, for his endless enthusiasm, support and collegial discussion which shaped and polished the content of the book, and for taking on more than his share of dog walks and washing up to ensure Brunel was given his due, even being one of 200 saxophonists playing for the Bridge celebrations! The book is dedicated to my grandfathers, my cherished link with quiet Victorian heroism, industriousness, engineering and the organisational skills which make the impossible possible!

First published in 2006 by Sansom & Company Ltd.,
81g Pembroke Road, Bristol BS8 3EA
www.sansomandcompany.co.uk
www.redcliffepress.co.uk
www.artdictionaries.com

ISBN 1 904537 50 2
© Claire O'Mahony
Published as part of Brunel 200 to coincide with an associated exhibition at Bristol's City Museum and Art Gallery
15 April : 18 June 2006 and funded by Bristol Cultural Development Partnership.

Designed and typeset by **Stephen Morris Communications, smc@freeuk.com**
Printed by Gutenberg Press, Malta

Contents

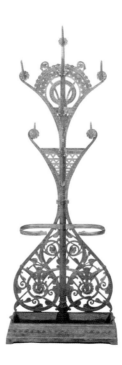

Hat Stand
Christopher Dresser
Victoria and Albert Museum

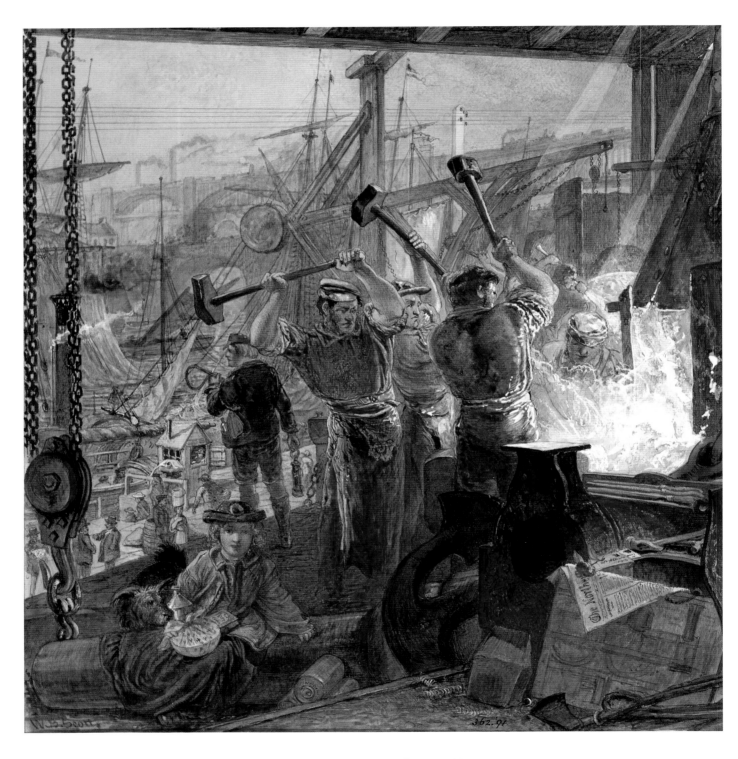

Iron and Coal, William Bell Scott, 1861
©Victoria and Albert Museum, London

Inventing Britain

Individuals, ideas and inventions all help to encourage creative partnerships between art, science and industry. The nineteenth century was distinctive in achieving such productive relationships across these different professions and ways of thinking. Inventors and their patrons offer inspiring role models; their creations helped shape modern life.

Brunel embodies the self-reliance, hard work and inventiveness which many have seen as the core achievement of the nineteenth century. Samuel Smiles (1812-1904) celebrated such heroes of modern industry and invention in *Lives of the Engineers* 1861-2; *Industrial Biography* 1863 and *Men of Invention and Industry* 1884. Smiles particularly admired men like George Stephenson and James Brindley, for having risen from the workshop to the boardroom through hard work and ingenuity. Smiles also advocated this intrepidness in a suite of books, which have also become a popular genre of writing in the twenty-first century: *Self Help* 1859.[1] Recently, Brunel and his contemporaries have once more been championed as 'men of iron' and 'Great Britons'. Robert Howlett's famous photograph of Brunel, *Brunel with chains,* has become an icon of this spirit of creative adventure. This man in 'love with the impossible', by sheer brilliance of invention and force of will, transformed modern transport, engineering and architecture. Popular and academic voices have reintroduced a generation to our Victorian heritage. These interventions have helped to redress the neglect or contempt of nineteenth-century creativity and hard work, but have often sidelined the artistry of these industrial achievements. These self-made inventors were shaped by a society that recognised the creative interdependence of the worlds of art, industry and science. This book, and the exhibition it accompanies, explores how the people and creativity which invented modern Britain were represented in art and writing.

Invention often demands sacrifice. Awareness of the Victorian legacy will be more long lasting and wide reaching, if it attends to the tensions as well as the triumphs of this age of invention.[2] Three artworks, Tony Forbes's *Sold down the River* 1999, Marc Quinn's Fourth Plinth sculpture 2005 and Antony Gormley's *Angel of the North* 1995-8 suggest the productive tensions central to this task. Forbes's self-portrait highlights the problems facing many young Britons when attempting to identify with history and heroes. Enchained, his eyes closed, Forbes cannot engage with the icons of British and Bristolian identity which surround him: the Colston statue, the *Matthew* ship and the Clifton Suspension Bridge. John Cassidy's Victorian monument to Edward Colston of 1895, in the central civic space of Bristol, typifies the dangers of an unnuanced triumphalism when representing history.[3] Colston's intrepid entrepreneurialism and the philanthropy it allowed are gracefully conveyed in his elegant pose and handsome plinth, but the statue ignores the taint of his involvement in the Royal African Company, which officially controlled the slave trade.[4] Through increasing awareness this statue can be transformed into an historical record of the silenced victims of Colston's trade as well as his philanthropy and Victorian admiration of his entrepreneurialism. Monuments are hugely resonant sites of history, providing traces of tragedies and triumphs and should be preserved. Marc Quinn's statue of *Alison Lapper Pregnant,* currently installed in Trafalgar Square on The Fourth Plinth, provides a heartening counterpoint to Cassidy's Colston. Disabled, pregnant, this woman represents identities and experiences which have rarely been celebrated in fine art or in public. This truly modern monument renders Lapper not only visible, but also invites us to reflect on the variety of forms inventiveness and heroism can take. Forbes's satire of the graceful beauty of the Clifton Suspension Bridge offers instructive warnings.

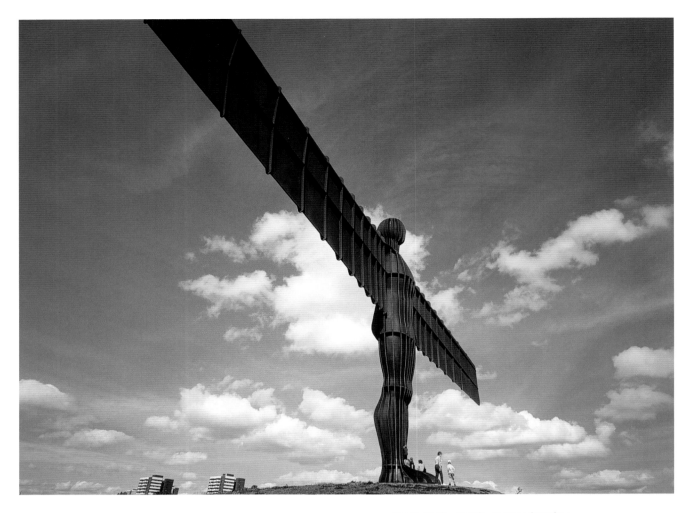

Angel of the North, Antony Gormley
Engineering by Arup. Photo: Doug Hall i2i

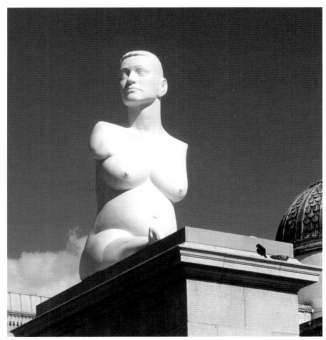

Alison Lapper Pregnant, Marc Quinn
© The artist, courtesy Jay Jopling/White Cube, London

His silhouetted revellers suggest a distant, unavailable party. The replacement of the bridge's majestic structural piers with videotapes alerts us to the importance of ensuring that heritage and history, whilst serving tourism and trade, also should encourage a sense of belonging. Antony Gormley has claimed such aspirations for his *Angel of the North* 1995-8 sculpture: 'My body is the location of my being…I turn to the body in an attempt to find a language that will transcend the limitations of race, creed, and language, but which will still be about the rootedness of identity.'[5] This monument is particularly resonant with the themes of the Brunel 200 celebrations. Science and engineering helped to construct it, art is the source of its inspiration and expression, industry is celebrated in its

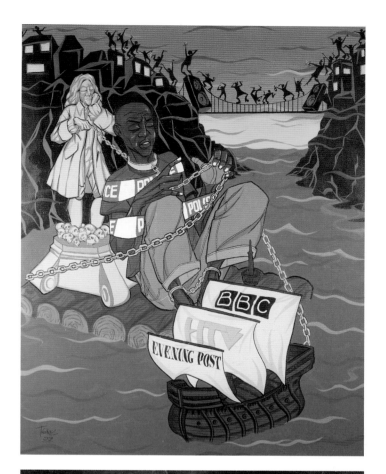

referencing of girders and the forms of transportation in its wings. The exhibition 'Brunel and the Art of Invention' also hopes to bring together different voices which helped to invent Britain, celebrating how culture and history belong to us all.

The following pages explore how the past can speak to the twenty-first-century debates about heroes and identity posed by Forbes and Quinn. Both famous heroes and silenced voices are vital; the art of invention in the past can help to kindle new possibilities in the future. Forbes's image demands the rediscovery of a wider spectrum of heroes who invented Britain. In many histories, Florence Nightingale has become synonymous with Victorian Britain. She determinedly fought to professionalise nursing and to demonstrate women's ability to undertake this specialist, hard work in the front line. However, in the Victorian era, another name was also on everyone's lips when speaking of these causes: Mary Seacole (1805-1881), a Jamaican woman who tended the sick in the Caribbean and Crimea.[6] Despite having a wealth of nursing experience tending military personnel, when Seacole attempted to volunteer at the outbreak of the Crimean War she was refused both by the War Office and Nightingale's expedition. Saddened but undaunted, Seacole funded her own passage with the help of a relative called Day, establishing the British Hotel and Store near Sebastopol where British soldiers could convalesce. As the war drew to a close, she had little funds and her unused store of expensive medicines forced her into bankruptcy. Happily her destitution was short-lived; two Crimean commanders – Lord Rokeby and Lord Paget – organised a vast fundraising banquet in her honour at the Royal Surrey Gardens.[7] Despite this tribute, her Crimean War Medal and her popular autobiography *The Wonderful Adventures of Mrs Seacole in Many Lands* published in 1857, she has only recently been widely recognised. A lifelong friend WH Russell, corre-

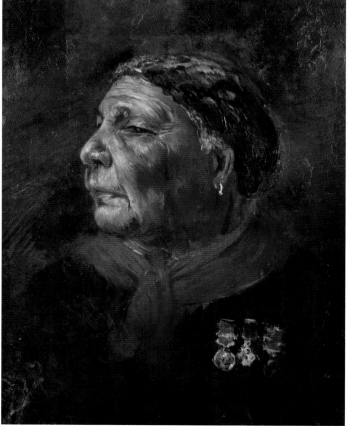

Shaftesbury or Lost and Found, William Macduff, 1862
© Museum of London

Playing Doctors, Frederick Daniel Hardy, 1863
© Victoria and Albert Museum

spondent for *The Times* who had befriended Seacole in the Crimea captures Mary Seacole's inventiveness:

> I have witnessed her devotion and her courage; I have already borne testimony to her services to all who needed them. She is the first who has redeemed the name of 'sutler' from the suspicion of worthlessness, mercenary baseness, and plunder; and I trust that England will not forget one who nursed her sick, who sought out her wounded to aid and succour them and who performed the last offices for some of her illustrious dead.[8]

Mary Seacole's life and portrait have a capacity to reconcile the contested but inter-related identities of Britishness and Blackness, womanhood and the front line. Challen's portrait captures her dignity with arresting simplicity and indicates her complex identity by juxtaposing her 'Creole' red scarf and her British imperial medals.[9]

Another way to uncover the art of invention is to examine the role models that children were encouraged to emulate. At first glance, when placed side by side with Forbes's eloquent critique and Quinn's celebratory egalitarianism, these Victorian images of worthy politicians and rosy-cheeked children may appear naively sentimental or patronising. Closer scrutiny reveals a lot more. As Lionel Lambourne has argued, Victorian story paintings encouraged a feeling of empathy with the otherwise invisible dispossessed and could inspire social change: 'it was precisely in their tendency to sentimentalise, to demand the response of compassion, that such works afforded powerful inducements to public humanitarianism.'[10] Two visions of earnest waifs and cosseted middle-class domesticity may serve to illustrate the historical richness and narrative complexity of these charming images. William Macduff's (fl.1844-1876) *Shaftesbury or Lost and Found* 1862 sanitises the hardships of homeless street children, but it also offers a useful testament to the role of eminent Victorians in transforming perceptions of childhood. Children are recognised as needing special protection and care through personal and political intervention. Two young bootblacks look into the window of Messrs. Graves's print shop. With an affectionate swagger, the older boy points out a portrait print of Lord Shaftesbury to his young companion. Prints of other famous paintings of charitable and redemptive acts such as John Everett Millais's *The Order of Release* and Thomas Faed's *Mitherless Bairn* in the window also connote the good deeds of pioneering reformer and philanthropist, Lord Shaftesbury. Anthony Ashley-Cooper, seventh earl of Shaftesbury (1801-1885), championed reforms such as the Factory Act of 1833 and the 1842 Mines Act. His intense evangelical faith, though problematically sectarian, inspired an impressive and active commitment to the protection of poor and vulnerable children and to the ten-hour working day. The box of polishing equipment and a flyer in the foreground also signify Lord Shaftesbury's causes: the Shoeblack Brigade, which boasted 306 members, and his presidency of the Ragged School Union from 1844.[11] Macduff, like Samuel Smiles, unquestionably champions

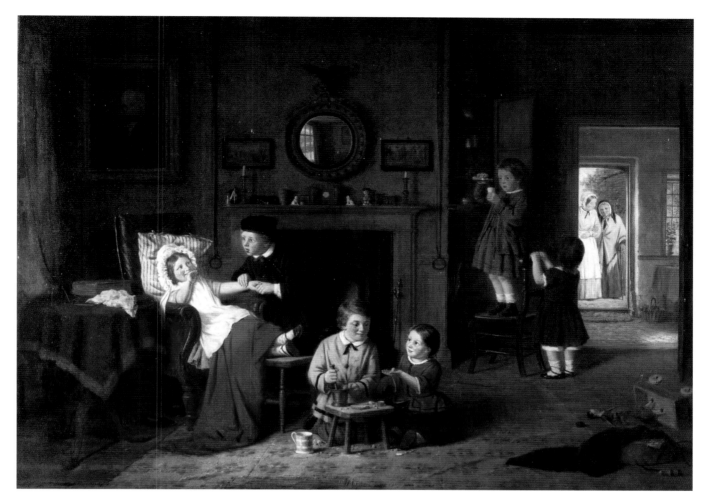

self-reliance, but also challenges the powerful to play their part in helping to realise the Victorian rags-to-riches dream.

If Macduff's image invites a re-evaluation of society's responsibilities, the children paintings of the Cranbrook colony celebrate the importance of play in shaping identity. A circle of painters, including Thomas Webster (1800-86), the Hardy brothers, Brunel's brother-in-law John Calcott Horsley (1817-1911) and George Bernard O'Neil (1838-1917), Horsley's godson, settled in the Kent village of Cranbrook in the 1850s. Frederick Daniel Hardy (1826-1911) often showed the typical large Victorian family, with children of different ages, 'playing' at adult role models and past-times. Paintings like Hardy's *Playing Doctors* 1863 helped to shape and to encourage Victorian admiration of the discoveries and commitment of modern medicine. It prefigures one of the most popular paintings of the Victorian era, Luke Fildes's *The Doctor* of 1891, commissioned by Sir Henry Tate. Engravings of this work were reproduced across the globe, over a million in America alone. Despite an all-night vigil with the local doctor, Fildes had lost his first child on Christmas Day 1877. He determined to paint a detailed evocation of the duty and commitment of the newly professionalised medical doctor. Both paintings capture the respect that the medical profession had gained in Victorian Britain; art becomes an eloquent advocate for recognising the worth of scientific enquiry and diligence.

Queen Victoria eloquently symbolises many aspects of nineteenth-century Britain; as Kingsley Martin claimed, 'Her prejudices and her convictions were so exactly those dominant in her age that she seemed to embody its very nature within herself.'[12] Her 63-year reign witnessed the triumph of the industrial transformations initiated in the

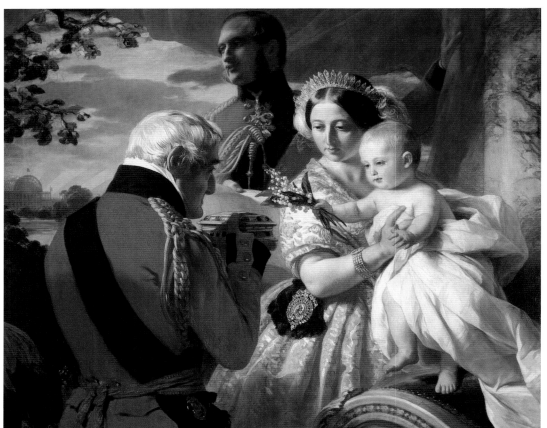

eighteenth century. The ships and railways pioneered by Brunel and his contemporaries consolidated the new markets and raw materials of the Empire, by force or negotiation. Portraits of Queen Victoria reveal the challenges of representing a female monarch. Her status as ruler must be balanced against her womanhood. Many painters emphasised her wifely and maternal virtue: a model of domesticity surrounded by her many children and indulged dogs, immortalised by Sir Edwin Landseer (1802-1873). Frans Xavier Winterhalter's (1805-1873) *The First of May 1851* fuses the traditional composition of medieval and Renaissance altarpieces which represent the Madonna and child receiving gifts from kings and shepherds alike, underlining the divine right of the monarch. The image also carefully juxtaposes the private and public lives of the monarch. 1 May 1851 was Prince Arthur's first birthday, as well as the inauguration day for the Great Exhibition. The exhibition was a key turning point in raising the profile of the monarchy and Queen Victoria's German consort, Prince Albert of Saxe-Coburg. The Duke

of Wellington was Prince Arthur's godfather. He is shown presenting his charge with a memorial casket, while Prince Arthur returns the compliment, offering the old soldier and confidant to the Queen a traditional May Day posy of lilies of the valley. Prince Albert, as consort, is made appropriately secondary to the monarch, smaller and more distant from the central action. Nonetheless, in keeping with Victorian gender roles, his encircling arm and high point in the triangle of figures signals his role as father and protector. His visionary gaze is directed towards the graceful glass-and-iron structure of Joseph Paxton's Crystal Palace beyond, an icon of Prince Albert's role in championing the nation's prosperity and inventiveness. This unprecedented structure and the educational exhibits it housed were designed by Joseph Paxton (1801-1865), another Samuel Smiles-style self-made man, who began as a gardener's boy and ended as a knight.[13]

A visual equivalent of Smiles's *Lives of the Engineers* is John Lucas's (1807-1874) *Conference of Engineers at Britannia Bridge*, 1851-3. Founded on 2 January 1818, the

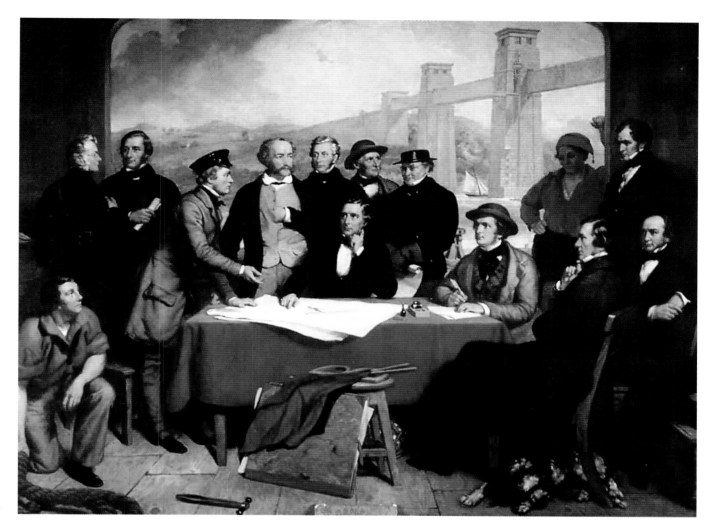

Institution of Civil Engineers received its Royal Charter in 1828, with Thomas Telford as its first president. Such organisations played a key role in establishing the professional status of civil engineering.[14] This impressive portrait was commissioned by the Institution to honour the building of Robert Stephenson's Britannia Bridge over the Conwy and the Menai Strait between the Welsh mainland and the island of Anglesey. It includes the most famous engineers of the day: Robert Stephenson (1803-59) in the centre, Isambard Kingdom Brunel (1806-1859) seated on the far right and Joseph Locke (1805-1860) next to him. Both Stephenson and Locke served as presidents of the Institution; Brunel was vice-president in 1850, but worn down by work and ill health, demurred at taking on the presidency in the last year of his life. Other sitters include the engineers George Parker Bidder (1806-1878),

Edwin Clarke (1814-1894), Latimer Clark (1822-1898) and Frank Forster (1800-1852). The Britannia Bridge formed an important transport link between London and Holyhead, the embarkation point for Irish Sea crossings. Thomas Telford had built a suspension bridge over the straits. Construction began in 1819 and the bridge opened on 30 January 1826, but it was unsuited to the heavy loading required by railway travel. Stephenson undertook the Admiralty's demanding challenge of devising a bridge 100 feet high to allow tall ships to pass beneath. He solved the problem by designing the longest bridge span in wrought iron yet attempted, formed by tubular segments which enclosed the railway track and trains. Whilst the tubular tunnel provided stability, the weight of 1,800 tons was also supported by masonry piers on the banks and Britannia Rock, and sixteen colossal iron chains, boiled in linseed oil

The Wealth of England:
The Bessemer Convertor (detail)
WH Titcomb, 1895
©Sheffield Industrial Museum

undertaking are suggested by the young man in a cap rushing in to seek guidance from Stephenson, who points with furrowed brow to the many plans on the table. The hastily cast-off cloak on the stool in the foreground involves us as viewers in the drama of thinking on one's feet.

Innovators in industry often made their start in art and design. Sir Henry Bessemer (1813-1898) was another remarkable nineteenth-century inventor, experimenting with electroplating, decorative bronze gilding paint and imitation velvet as well as sugar-refining machinery, glass plates, and pencils. He resolved the problem of fraudulent reuse of affixed stamps on deeds which cost the Stamp Office £100,000 a year, by creating elaborate perforated die stamps.[15] Both Brunel and Bessemer were eager to contribute to the British involvement in the Crimean War of 1854-6. Brunel sent well developed plans to the Admiralty for semi-submersible gun batteries and a

to prevent rusting. Stephenson's achievement was an important precedent for Brunel's Royal Albert Bridge over the River Tamar at Saltash. Having taken six years to complete, the Britannia Bridge opened on 5 March 1850. Lucas infuses his portrait with a sense of immediacy true to the dramatic profession of its sitters, portraying them not in an elegant meeting room or enjoying the pomp of an opening ceremony, but instead on the bare floorboards of a site hut. The inclusion of two labourers in red shirts and caps underlines the close working relationships between inventive engineers and the men carrying out their work. The challenges which arise at every stage of such a complex

polygonally bored rifle without success, but an Under-Secretary in the War Office did finance Brunel's plans for a prefabricated field hospital, built at Renkioi on the shores of the Dardanelles.[16] The British government was equally unsupportive of Bessemer's experiments with heavy artillery shells. After undertaking trials funded by Emperor Napoleon III of France, Bessemer was convinced a cheap method of producing steel was the real challenge.[17] As the Ancient Chinese and the Haya people of sub-Saharan Africa had determined thousands of years before, Bessemer realised the problem of refining pig iron into steel was easily overcome by blowing air through the

Teaching diagram of plant structure, Christopher Dresser © Victoria and Albert Museum

molten iron, removing the impurities. Bessemer patented his process in 1855; the Bessemer converter, a large oval-shaped furnace lined with clay or dolomite with an open end, was instrumental in the mass production of 'mild' steel. Bessemer mass produced steel at his works in Sheffield which was much stronger than wrought iron, and although less pure than tooled steel was infinitely cheaper. Most of the heavy engineering of Victorian Britain – the bridges, railways and ships – were made of this material. The theatrical light effects of furnaces had inspired many eighteenth- and early nineteenth-century artists including Joseph Wright of Derby (1734-1797), Philip de Loutherbourg (1740-1812) and John Martin (1789-1854), whom Brunel particularly admired. W H Titcomb's (1858-1930) dramatic painting *The Wealth of*

England: The Bessemer Convertor 1895 captures the excitement of Bessemer's oxidation process, when sparks erupt like fireworks: an industrial variant of James McNeill Whistler's controversial *Nocturne in Black and Gold: The Falling Rocket* 1876.[18]

Best known for his ceramic and flat pattern design, Christopher Dresser (1834-1904) also combined knowledge, skill and experience in the fields of botany and art education, and managed business ventures in art furnishings. At the precocious age of thirteen, Dresser entered the Government School of Design, where he studied botany and design. This educational environment was reverberating with the new attitudes to decoration elaborated by Richard Redgrave (1804-1888), Sir Henry Cole (1808-1882), Owen Jones (1809-1874), and Augustus Welby

Northmore Pugin (1812-1852). Cole, founding Director of the South Kensington Museum (now known as the Victoria and Albert Museum), was Secretary to the Department of Science and Art, a government office which bespeaks the close collaboration in the nineteenth century between these now often quite separate fields of study. Dresser lectured on Botany in the Department of Science and Art and at St Mary's Hospital, receiving an honorary doctorate in Botany from the University of Jena, Germany in 1859. He contributed plate 98 to Owen Jones's ground-breaking *Grammar of Ornament* published in 1856.[19] The plate captures the intimate links between scientific enquiry and artistic ornament, highlighting the inspiring potential of a knowledge of plant morphology and growth patterns. These interconnections were later explored in the scientific treatises of Charles Darwin, *The movements and habits of climbing plants* London: Murray, 1888 and the organicism of British designers like Arthur Heygate Mackmurdo (1851-1942) and continental Art Nouveau. Dresser travelled to the United States and Japan in 1876-7, lecturing but also learning about design. His *Japan Its Art, Architecture and Art Manufactures* of 1882 is one of the few Japonist texts which is based on first-hand experience. Dresser was a committed industrial designer working with over fifty manufacturing firms, as well as running several more or less successful design studios of his own, most notably the Art Furnishers' Alliance where he employed over twenty studio assistants including Archibald Knox (1864-1933), famously associated with the 'Liberty' Style.[20]

Industrial and technological innovation came at a price: the contrast of desperate poverty with progress and affluence was a constant feature of

HINDOO TRACT-SELLER.

[From a Daguerreotype by BEARD.]

THE BLIND BOOT-LACE SELLER.

[From a Daguerreotype by BEARD.]

THE SWEEPS' HOME.

(From a sketch taken on the spot.)

HENRY MAYHEW.

[From a Daguerreotype by BEARD.]

London Labour and the London Poor, Henry Mayhew, 1851-62 ©University of Bristol

17

Applicants for Admission to Casual Ward, Sir Luke Fildes, 1874. © The Picture Collection, Royal Holloway, University of London

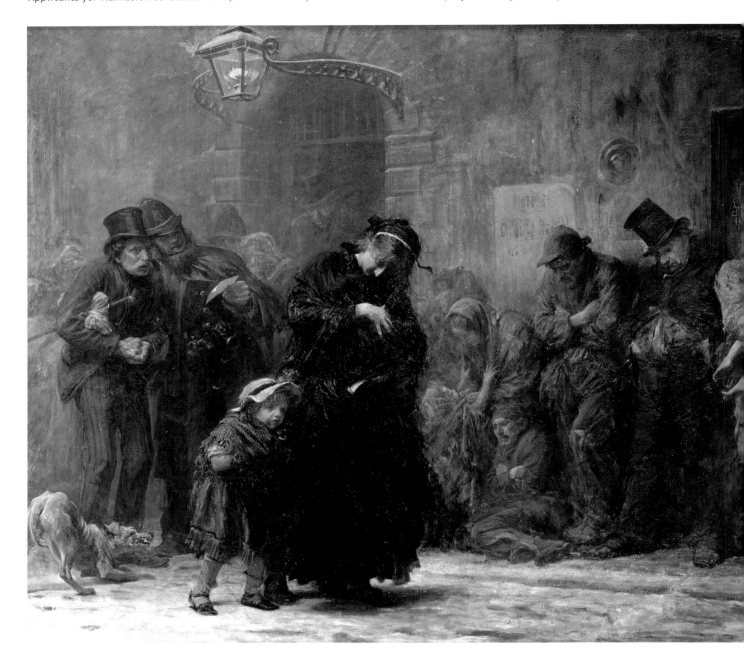

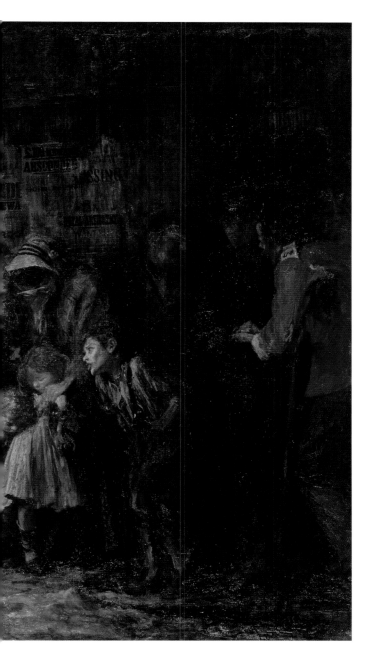

nineteenth-century life. The vibrancy of unfettered free trade and the fortunes it created was fickle. Living conditions in many industrial towns were appalling with rudimentary or non-existent sanitation, overcrowding, pollution and poorly paid and irregular work. John Ruskin and William Morris eloquently critiqued the potentially alienating effects of modern labour in public lectures and writings.[21] Anxiety about social ills featured in countless parliamentary papers, such as Edwin Chadwick's *Inquiry into the Sanitary Condition of the Labouring Population of Great Britain*, 1842 which revealed that twice as many people died annually from typhus than had died at the battle of Waterloo. Henry Mayhew created the most comprehensive and emotionally charged documentation of these conditions, published first in serial form then as an illustrated four-volume work *London Labour and the London Poor* 1851-62. Despite its philanthropic aims, it makes disturbing reading from the viewpoint of the twenty-first century, describing London's poor as a race apart.[22] The structure of Mayhew's analysis, grouping the world into classificatory types of people, much like zoological or botanical texts of the period, reflects the impact of new 'sciences' of ethnography and anthropology. Such documentary texts also exerted a strong influence upon art and literature. Many novelists used these horrifying statistics to create highly detailed, emotionally charged narratives. Mrs Frances Trollope (1780-1863) witnessed the abuses of child labour in northern cotton mills, and was moved to write *Life and Adventures of Michael Armstrong, the Factory Boy* 1840. She chose the novel form in the hope that it would attract more powerful advocates to the reformist cause of Chartism than political speeches could. Benjamin Disraeli (1804-1881) created a rather more fantastical scenario of a Chartist activist with a medieval aristocratic past in *Sybil: Two Nations*, 1845. Charles Kingsley (1819-1875) also contributed to this lit-

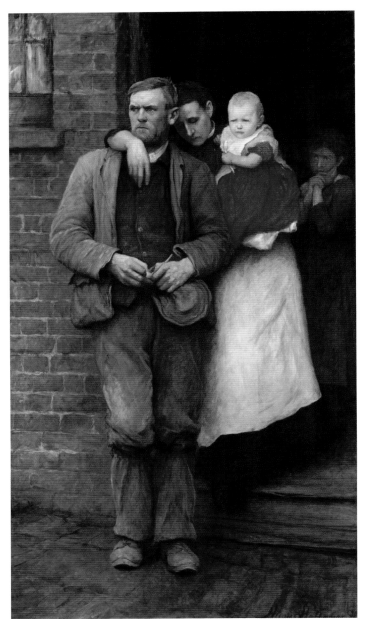

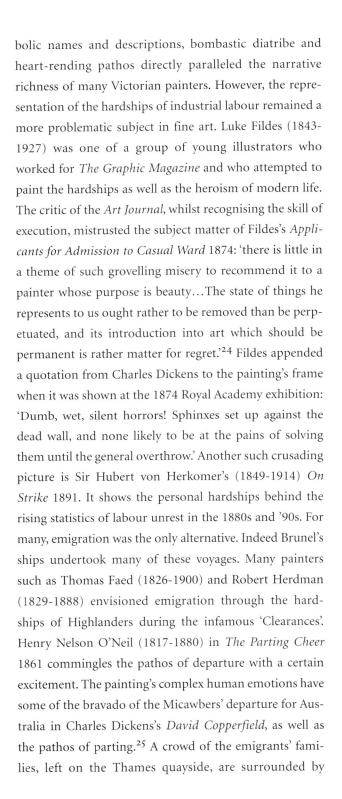

bolic names and descriptions, bombastic diatribe and heart-rending pathos directly paralleled the narrative richness of many Victorian painters. However, the representation of the hardships of industrial labour remained a more problematic subject in fine art. Luke Fildes (1843-1927) was one of a group of young illustrators who worked for *The Graphic Magazine* and who attempted to paint the hardships as well as the heroism of modern life. The critic of the *Art Journal*, whilst recognising the skill of execution, mistrusted the subject matter of Fildes's *Applicants for Admission to Casual Ward* 1874: 'there is little in a theme of such grovelling misery to recommend it to a painter whose purpose is beauty…The state of things he represents to us ought rather to be removed than be perpetuated, and its introduction into art which should be permanent is rather matter for regret.'[24] Fildes appended a quotation from Charles Dickens to the painting's frame when it was shown at the 1874 Royal Academy exhibition: 'Dumb, wet, silent horrors! Sphinxes set up against the dead wall, and none likely to be at the pains of solving them until the general overthrow.' Another such crusading picture is Sir Hubert von Herkomer's (1849-1914) *On Strike* 1891. It shows the personal hardships behind the rising statistics of labour unrest in the 1880s and '90s. For many, emigration was the only alternative. Indeed Brunel's ships undertook many of these voyages. Many painters such as Thomas Faed (1826-1900) and Robert Herdman (1829-1888) envisioned emigration through the hardships of Highlanders during the infamous 'Clearances'. Henry Nelson O'Neil (1817-1880) in *The Parting Cheer* 1861 commingles the pathos of departure with a certain excitement. The painting's complex human emotions have some of the bravado of the Micawbers' departure for Australia in Charles Dickens's *David Copperfield*, as well as the pathos of parting.[25] A crowd of the emigrants' families, left on the Thames quayside, are surrounded by

erary genre with *Yeast*, 1848 and *Alton Locke*, 1850, as did Charlotte Brontë (1816-1855) with *Shirley*, 1849. Perhaps the most famous of the Victorian industrial novels are Mrs Gaskell's *Mary Barton*, 1848, *North and South*, 1855, and Charles Dickens's (1812-1870) *Hard Times,* 1854. Mrs Gaskell was a first-hand witness to the hardships of working-class life in Manchester, as the wife of a Unitarian minister and an organiser of relief during the 1862 'cotton famine'.[23]

Dickens's ruthless satire is unmatched; its use of sym-

belching smoke and ships. This extraordinary social panorama shows the poor – a ragged orange seller and a sailor's family – left to fend for themselves, and the well-to-do, a widow and her children accompanied by a terrier. These Londoners are contrasted with the country family, with ruddy cheeks and rolled-up sleeves at the back of the crowd. A black man, also at the back of the crowd on the left, is O'Neil's declaration of solidarity with the abolitionist cause, a hot topic in 1861, when O'Neil is painting, at the outbreak of the American Civil War. Travel, its delights and perils, is another key theme which manifests the art of invention.

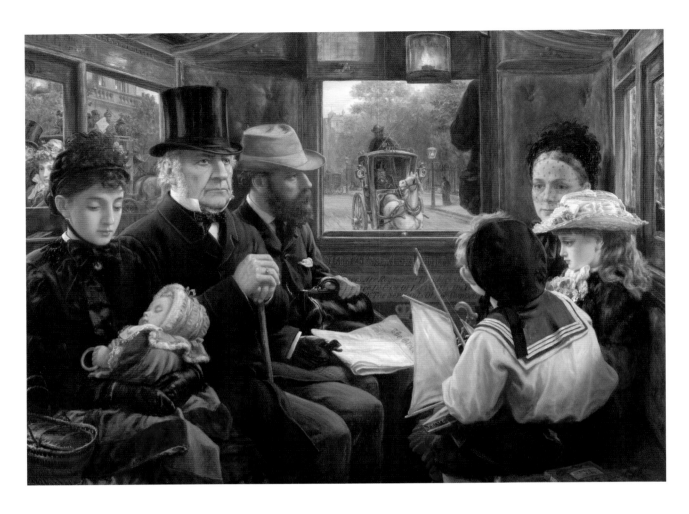

An Omnibus ride to Piccadilly Circus Mr Gladstone travelling with ordinary passengers, Alfred Morgan, 1885
© Richard Green Galleries

Travel and Transport

Brunel helped to invent new forms of transportation, from public railways to iron ships; he even drew up plans for an airship. New ways of travelling created new encounters and experiences. The expansion and affordability of the railways meant that ordinary men and women could travel in large numbers for the first time. Commoners and kings might rub shoulders under the vast iron-and-glass roof of Paddington railway station or on a London omnibus. However, the stories played out in the different 'class' carriages on the trains reveal that these voyages often led to strikingly different destinations. Travel also helped to build and to enforce British imperial presence around the world. Ships like the ss *Great Britain* transported trade goods, soldiers and settlers to and from every corner of the globe. These early difficult voyages helped to bring about the romance and glamour of the ocean liners of the twentieth century and beyond.

Alfred Morgan's (1835-1924) *An Omnibus ride to Piccadilly Circus Mr Gladstone travelling with ordinary passengers* 1885 is a delightful study of the chance encounters of modern travel. William Ewart Gladstone (1809-1898) sits lost in thought, surrounded by a middle-class family, modelled by the artist and his family.[26] Gladstone was a key figure in Victorian political and industrial life. He entered the House of Commons in 1832 as Conservative candidate for Newark, later serving as Vice-President, then President of the Board of Trade, Chancellor of the Exchequer, with four terms as Prime Minister. An article in the *Daily News* reflected on the positive impact the painting had in conveying Gladstone's accessibility to the nation:

> The picture gallery and the art students' exhibition were thronged, and it is worthy of note that in the former Mr. A. Morgan's painting 'A Ride to Piccadilly-Circus' was an object of unfailing interest. It shows Mr. Gladstone in an omnibus full of passengers, one of whom is amusingly represented with a Conservative newspaper displayed on his knee. As the groups of people passed, one or another would recognise the face of the right hon. Gentleman and would call his companions to look at it, so that Mr. Gladstone might be said to be holding a popular reception all through the day.[27]

Gladstone had played a key role in the passage of the Railway Bill of 1844, which greatly improved the conditions of third-class travel, requiring seats and protection from the weather. It also forced firms to provide at least one train a day that stopped at every station on the line, outward and return, at a regulated fare of no more than one penny a mile and at 'a speed not less than twelve miles an hour including stoppages'.[28] Morgan refers to Gladstone's commitment to fair standards of travel for passengers of a more modest means by showing him on a London omnibus.

The environments and experiences of different classes of rail travel was a favourite motif for Victorian artists. Abraham Solomon (1824-1862) attentively compared these different worlds in *First Class – The Meeting* and *Second Class – The Parting*, 1855. The two interiors are starkly contrasted: one plush and inviting the other of bare wood apart from commercial advertisements on the wall.[29] The different critical reactions each work solicited was striking. Solomon felt obliged to repaint the first-class scene which had attracted accusations of impropriety. The original version, now in the National Gallery, Ottowa, shows a young man leaning forward, resting his chin on his hand to stare admiringly at a pretty young girl. She toys with her necklace from which a tiny key is suspended – perhaps the key to his affections? – while her father sleeps unawares, a newspaper abandoned on his lap. Although the girl glances away demurely, the

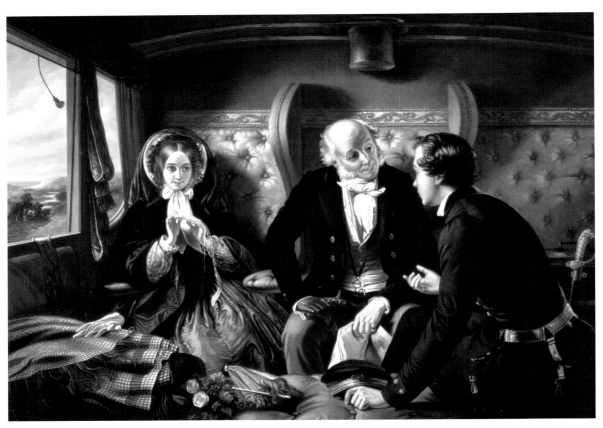

*First Class –
The Meeting*,
Abraham
Solomon, 1855

©Southampton City
Art Gallery,
Hampshire, UK

*The Railway
Station*,
William Powell
Frith, 1862

©The Picture
Collection,
Royal Holloway,
University
of London

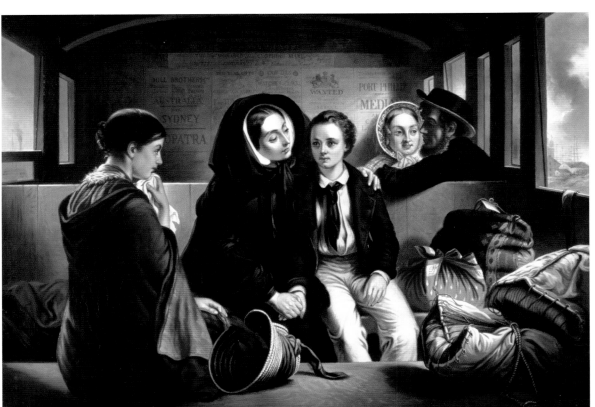

*Second Class –
The Parting*,
Abraham
Solomon, 1855

©Southampton City
Art Gallery,
Hampshire, UK

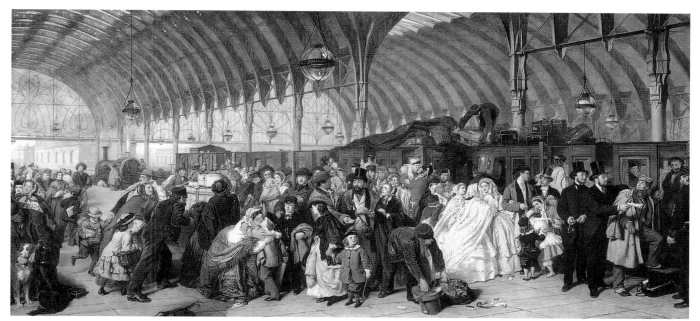

potential for romantic interlude was not lost upon the reproving critics. The *Art Journal* critic decried Solomon's misuse of his talents: 'It is to be regretted that so much facility should be lavished on so bald – or vulgar – a subject', while 'Rhadamanthus' in *Punch*, saw the humour in the scenario. 'I admit that the old gentleman sleeping in the sunlight is capital, but the young lady looks to me to be affected and the 'gent', I fearlessly assert, will maintain to be an arrant spooney.'[30] In the revised version, the father is awake and securely positioned between girl and youth. The young man has been transfigured from top-hatted dandy to reliable naval officer, the dubious associations of a fishing rod in the first version replaced by his officer's upstanding sword. *Second Class – The Parting* attracted no such controversy. Its subtitle, 'Thus part we rich in sorrow, parting poor', and the composition offered a reassuringly moral, if melancholy, glimpse of a boy about to leave his mother and sister. The *Art Journal* and *Punch* critics both identified the parting child as a sailor boy, accompanied by his widowed mother and sister on the train to his departing ship: 'The story of the widowed mother accompanying her boy, perhaps her only son, in the railway carriage to the seaport where he is to join his ship, is told with deep pathos: one can sympathise with the poor woman's heart trouble, we feel her grief to be genuine at the thought of parting, nor is the lad, though he strives to put a cheerful face on the matter, without some strong feeling of inward sorrow.'[31] The posters on the back wall might also imply the boy is emigrating to Australia.

Unlike the discrete worlds of classed railway carriages, in the stations all walks of life rubbed shoulders. William Powell Frith (1819-1909) had already captured the Victorian public's imagination with the panorama format of *Life at the seaside* of 1854 purchased by Queen Victoria and *Derby Day* of 1858. In *The Railway Station* 1862, he turned his eye to every detail of the modern railway, from the airy iron and glass architecture of Brunel's Paddington Station to the infinite variety of passengers about to depart. Frith took great pains to achieve accuracy in his representation; recognising his own limitations, he enlisted a young architect, W Scott Morton, to paint the architectural details of the station itself. The locomotive was painted from a photograph of *The Sultan*. Frith playfully includes many portraits; Louis Flatow, Frith's print dealer who helped to plan the panoramic detail eager to ensure the success of the print, is the portly gentleman admiring the locomotive. Frith and his own family were the models for the central group parting from their two sons, about to return to boarding school. At the far right of the composition, a

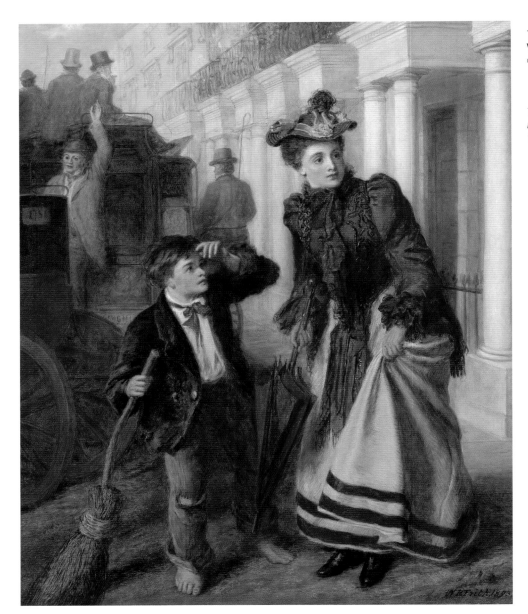

The Crossing Sweeper,
William Powell Frith, 1893
©Richard Green Galleries

*The expression of the emotions in
man and animals,* Charles Darwin,
1888 ©University of Bristol

man about to escape onto the train is arrested by two police-sergeants, modelled by Haydon and Brett, well-known detectives of the day. The vignettes are many and marvellous: new recruits in tasselled caps return to their barracks; a London cabbie importunes a moustachioed European visitor for a larger tip; a newly wed couple are embarking on their honeymoon.

As Mary Cowling has persuasively argued, these closely observed figures reflect one of the most wide-reaching ways that art and science interacted in Victorian Britain. Artists and writers inspired by the new social sciences of anthropology and ethnology, and later by the evolutionary theory of Charles Darwin applied a similar system of typing and classification to the artistic represen-tation of modern society:

> The first task that confronted anthropologists was the classification of the various races of mankind. Anatom-ical features, of which the shape of the skull was the most important, physiology, skin colour and hair texture were all carefully measured and tabulated. These studies pro-vided the basis for further comparative studies of the psychological, sociological and cultural characteristics of the various races, nations and tribes of the world.[32]

The study of physiognomy, extrapolating personality

Heliotype

from the analysis of facial characteristics, had been a core inspiration for the journalist Henry Mayhew, whose *London Labour and the London Poor* 1851-62 provided a rich resource for artists and writers. His involving narratives and illustrations of chimney- and crossing-sweeps, sellers of tracts, boot laces and bird nests offer a fascinating panorama of the social diversity of Victorian London, where Hindu and Irish, newly arrived country youth and disabled urbanite all live side by side. This way of seeing the world was popularised to an even wider audience by the novels of Dickens and the paintings of Frith, both through his panoramas and smaller works like *The Crossing Sweeper* 1893.[33] Dickens uses the sounds of names in the same way that Frith emphasises heavy brows or a delicate mouth to underline the physiognomy of moral character. In *Hard Times*, Thomas Gradgrind is recognizably heartless and mechanistic because of his name, just as Mr Bounderby cannot be a responsible businessman.[34] Ephemeral objects like a souvenir scarf of the 1851 Crystal Palace Exhibition or the physiognomic cartoons in

27

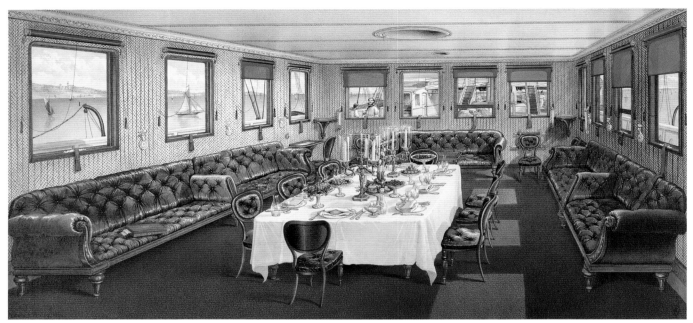

Interior of Royal Yacht Victoria and Albert II; Dining Saloon, Edwin Aaron Penley, 1864 The Royal Collection © 2005, Her Majesty Queen Elizabeth II

Souvenir scarf of the 1851 Crystal Palace Exhibition Private Collection

Punch further attest to such social typing. Charles Darwin's *The expression of the emotions in man and animals* of 1888 legitimised these ways of seeing even further.[35]

The desire to explore and to quantify the world was hugely assisted by the efficient new ships pioneered by Brunel and his contemporaries. Victorian transport served the causes of science, trade, tourism and colonialism. Another celebrated pair of paintings by O'Neil

illustrate the central role of shipping, but also art, in consolidating the Empire. *Eastward Ho! August 1857*, 1857 and *Home Again* (*see* pages 30 and 31), 1858 portray the transport of British troops from Gravesend to India during the 'Mutiny' and their subsequent return. Every inch of the composition has a different heart-wrenching parting, full of narrative. At the upper left a subaltern abandons traditional propriety, passionately kissing his wife. A sister waves to her brother while their widowed mother buries her face in a handkerchief. A Chelsea Pensioner points to his medals encouraging his grandson to equal valour. The success of *Eastward Ho!* inspired O'Neil to paint the sequel *Home Again* where many of the same soldiers and their wives are shown being reunited after the conflict. The youthful clean-shaven able-bodied men return older, bearded and maimed. These losses are matched by new-found manhood, the young rifleman shows his grandfather his Victoria Cross; the widow's son is now an officer.[36]

Eastward Ho!, exhibited during the height of the conflict, was heralded in the *Illustrated London News* as 'almost a national epic'.[37] The painting had been instrumental in rousing patriotism during this problematic moment of British imperial history.[38] The pair was also

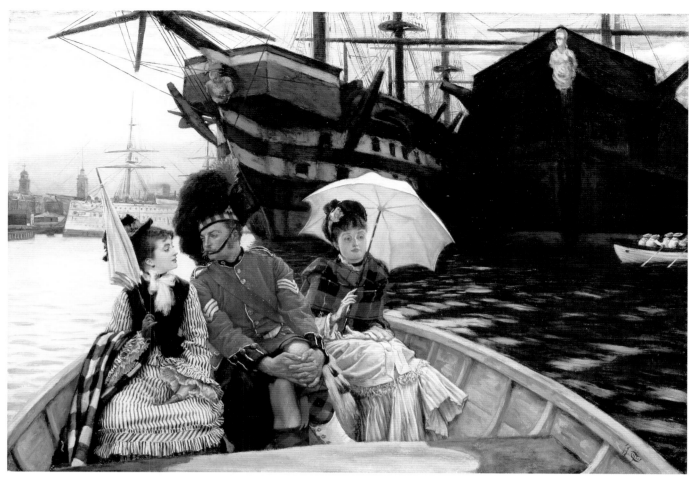

Portsmouth Dockyard, James Tissot, 1877 ©Tate London, 2005

exhibited at the International Exhibition held in London in 1862; the *Art Journal* reviewer explicitly aligned the modernity of the paintings and their subject matter with the spirit of progress and invention so often associated with Brunel:

> …this school of pictorial art is emphatically English …because we are daily making to ourselves a contemporary history… Britain is a land of action and of progress, trade and commerce, growing wealth, steadfast yet ever changeful liberty; a land and a people where in contemporary art may grow and live, because in this actual present hour we act heroically, suffer manfully and do those deeds which in pictures and by poems, deserve to be recorded.[39]

From the standpoint of the twenty-first century, the imperial slant of O'Neil's interpretation of the Indian Mutiny, and its critical reception are disquieting, but these arresting words and images do offer a unique insight into the world that Brunel helped to create. O'Neil, like Brunel or Paxton, helped to make modern experience a subject equally worthy and involving as Classical Antiquity or the Middle Ages.

Not all sea travel was so tortuous. Edwin Aaron Penley's view of the *Interior of Royal Yacht Victoria and Albert II; Dining Saloon*, 1864 reveals the lavish surroundings enjoyed by Royal passengers. Penley's view signals the domesticity of these floating holiday homes, underlined by the presence of Osborne House on the left. As Thomas Gibson Bowles admitted: 'we little coasting yachts, who only pretend to go to sea, and who are never really happy till we are tied to the side of a quay, with blue or white ensign flying and a party of ladies on board to lunch, are the most arrant imposters of all England.'[40] This judgement is perhaps harsh; ships have also always provided colourful settings for romance, from Charles Ryder and Julia Flyte

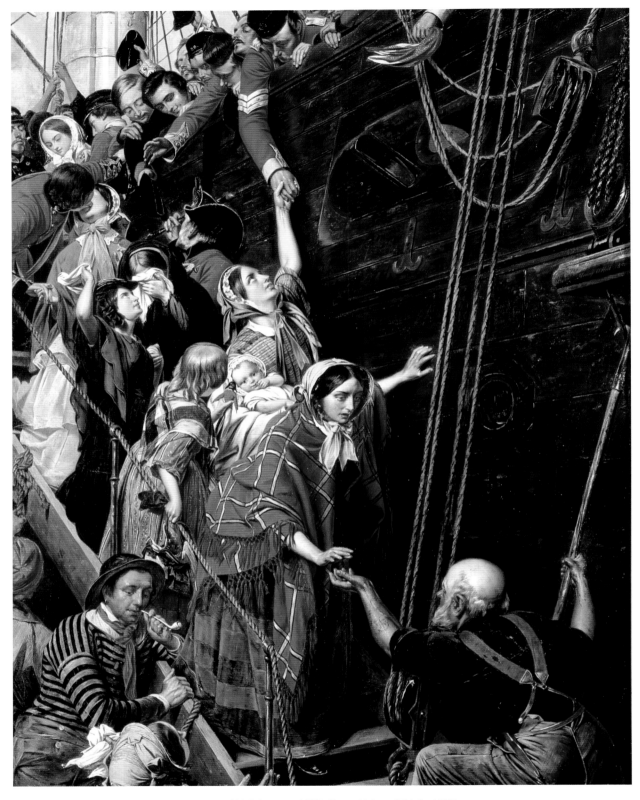

Eastward Ho! August, 1857, Henry Nelson O'Neil, 1857
© Museum of London

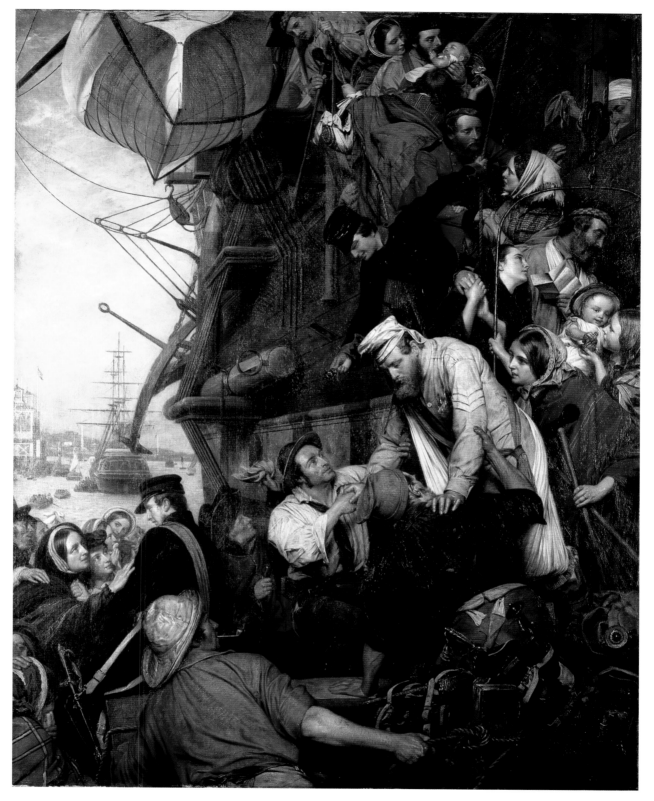

Home Again, Henry Nelson O'Neil, 1858
© Museum of London

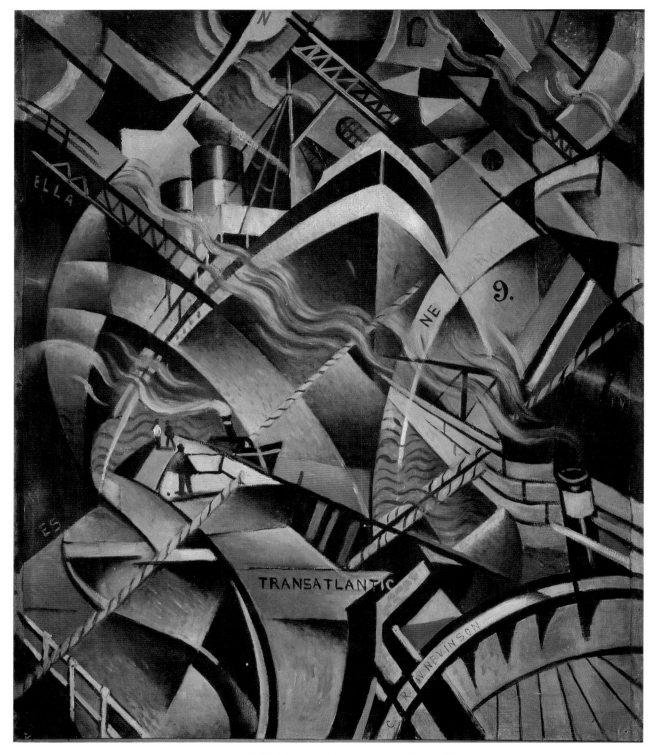

The Arrival, Christopher Richard Wynne Nevinson, 1913
© Tate London 2005

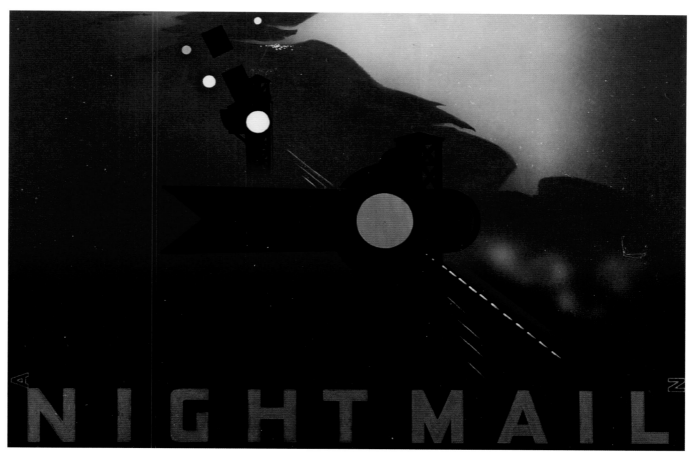

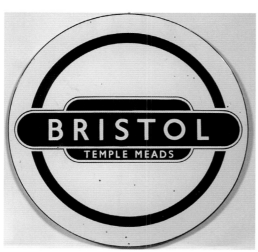

Poster for GPO film *Night Mail*, 1936
© Royal Mail Group PLC, 2005, with kind permission
from The British Postal Museum and Archive

Bristol Temple Meads roundel, 1950s
© Bristol's Museums, Galleries and Archives

in Evelyn Waugh's *Brideshead Revisited*, 1945 to Cary Grant and Deborah Kerr in the classic film *An Affair to Remember*, 1957. James Tissot's (1836-1902) *Portsmouth Dockyard* 1877 offers a delightful example of the open narratives of shipboard romance which were Tissot's forte. Indeed, as Nancy Marshall has observed, a lack of reassuringly clear moral in these story pictures was one of the principal critiques lodged by British critics against the French Tissot.[41] The elegant gallery of the HMS *Calcutta* in Portsmouth Harbour provides a handsome backdrop for the conundrum of a Royal Highlander seated between two beauties. Tissot's title for the print after the work, *How Happy I could be with Either*, a lyric from *The Beggar's Opera* 1728 emphasises his happy dilemma. The fashionable rivals for the soldier's attention are charmingly echoed in the carved figureheads on the ships' sterns above the group.

The streamlined volumes and gigantism of twentieth-century liners, the progeny of Brunel's vast *Great Eastern*,

A Thames Tunnel peep show Private Collection

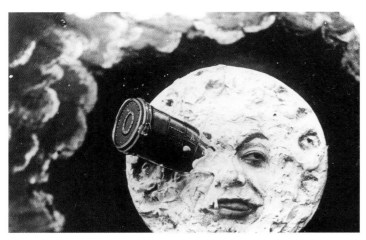

A Train arriving at La Ciotat (L'arrivée d'un train à la Ciotat),
Lumière brothers © British Film Institute

A Trip to the Moon (Le voyage dans la lune) George Méliès
© British Film Institute

The Pegasus engine © Bristol's Museums, Galleries and Archives

had a huge impact on twentieth-century art and design. The dynamism and swelling profiles in CRW Nevinson's *The Arrival* 1913 capture the ship's majestic simplicity and the excitement of its modern speed. A reviewer, troubled by the fragmentary force of Nevinson's composition, nonetheless acknowledges the impressive synthesis of speed and communication in this 'simultaneous' image: 'It resembles a Channel steamer after a violent collision with a pier. You detect funnels, smoke, gangplanks, distant hotels, numbers, posters all thrown into the melting pot, so to speak. Mr. Nevinson acted as interpreter, explaining that it represented a state of simultaneous mind.'[42] This simultaneous way of seeing has its origins in the optical illusions of nineteenth-century peep shows, stereoscopic photography and film. It is striking that perhaps the most famous early cinematic feature is Lumière Brothers footage of *A Train arriving at La Ciotat (L'arrivée d'un*

train à la Ciotat), which made the audience shriek and duck, for fear of being crushed by the oncoming train. Another pioneer of early cinema, the magician George Méliès, often chose travel as his theme. His most famous film, *Le voyage dans la lune* (*A Trip to the Moon*) of 1902 imagines a bullet-shaped rocket which hits the Moon's face in the eye. Interestingly the less well-known, *Le voyage à trâvers l'impossible* (*The Impossible Voyage*) of 1904 shows the continued resonance of the railways; this time a train shoots up from a mountain railway driving into the Sun's yawning mouth. Many artists embraced the austere grace of ocean liners' design with renewed vigour after the horrors of the world wars. The poster for John Grierson's famous film celebrating the mail train's nightly journey from London to Glasgow captures the efficiency and charm of the golden age of railways, much as WH Auden's poem and Benjamin Britten's score do in the film itself. The Bristol Temple Meads station sign circa 1950 is typical of the ways modernist designers at the Bauhaus and the Paris 1925 Exhibition embraced these forms. Travel and its representation had come a long way since Frith worried that Paddington Station was not picturesque enough to paint. In *Vers une Architecture* (*Towards an Architecture*) of 1923, Le Corbusier articulates this purifying spirit which saw the beauty of industrial design, championing 'a moral sentiment in the feeling for mechanics'.[43]

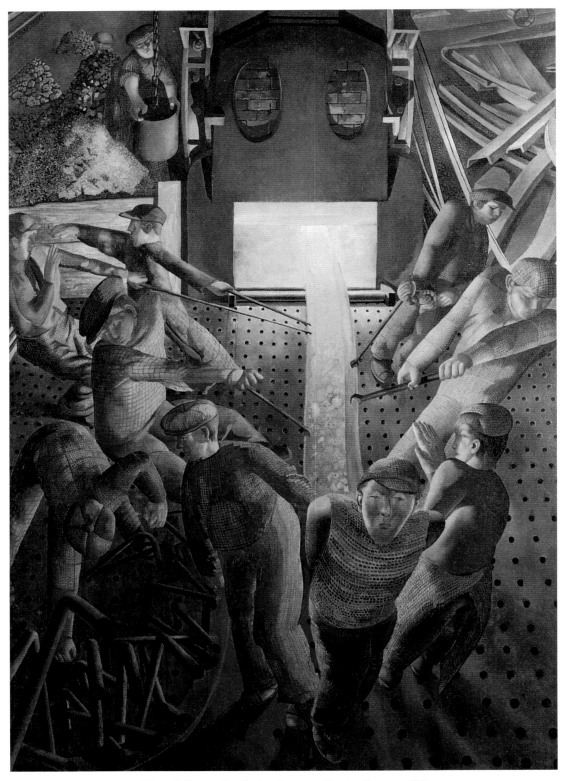

Shipbuilding on the Clyde: Furnaces, Stanley Spencer, 1946
© Imperial War Museum

The Art of Work

Art and industry have often been seen as opposites. But artists have frequently been inspired by industrial labour and industry relies upon artistic invention to achieve its ends and render them palatable. Thousands of ordinary working people contributed to the creation of Brunel's ships, railways and buildings. Art has often portrayed these unsung heroes, from the Victorian navvy to the women who entered the factories to serve the industrial needs of wartime.

Work in all its forms was championed in the nineteenth century as a manifestation of moral fibre. Thomas Carlyle in *Sartor Resartus*, 1833-4 and *Past and Present*, 1843 had importantly defined all labour, manual as much as intellectual, as having redemptive qualities: 'All work, even cotton spinning is noble…there is a perennial nobleness and even sacredness in work…In Idleness alone is there perpetual despair.'[44] William Bell Scott's (1811-1890) *Iron and Coal*, 1855-61 captures this belief in the sanctity of manual work, which built the inventive technologies and industrial might of Victorian Britain. Sir Walter and Lady Trevelyan commissioned Scott to create an ensemble of mural paintings for their country house, Wallington Hall in Cambo. The theme of the series was Northumbrian achievements throughout history. Earlier panels in the series celebrate the builders of the Roman wall and the medieval theologian known as 'the Venerable Bede' who died at Jarrow Abbey. *Iron and Coal* provided the final crescendo for the ensemble, celebrating the important role that Newcastle played in the industrial revolution. Scott's subtitle explains: 'In the Nineteenth Century the Northumbrians show the world what can be done with iron and coal'.

Scott visited Robert Stephenson's engineering workshop on Tyneside whilst he was planning the mural and drew his workmen from the life.[45] Every detail of the composition highlights the success and future progress of Northumbrian industrial innovation and might. Reminiscent of the blacksmiths in the forge paintings Joseph Wright of Derby created sixty years earlier, Scott's image shows the impressive strength of these hammering labourers as peaceful and productive, harmonised in a unified rhythm. Their hard work and resourcefulness have created the comfort and education enjoyed by the next generation, personified by the girl and boy to the left of the composition. The rosy-cheeked young girl has ample food; a packed lunch for her father is eagerly sniffed by a black dog. The book on her lap symbolises her education; her pretty bonnet and ornamental scarf underline the comfort of her upbringing. The pit boy beyond is equally healthy; he gazes out over a bright future symbolised by the industrial panorama of the quayside.

Both the workshop and the vista beyond are full of feats of engineering and industry. Critics have variously interpreted these ultimate products of the workmen's labour as a ship's engine, a weighty anchor dominates the foreground, and guns and shells, the girl sits on the body of an Armstrong gun, beside stacked shells.[46] The girl's posture, like the rhythmic gesture of the workmen, reassures us that this weapon is calmed, but ready. Her perched form is echoed in the red rose to the right. This flower is poised on top of a set of objects evoking communication, trade and travel: a stack of letters, a newspaper with the banner 'Northern' and a mechanical drawing, probably for a new passenger locomotive designed by Robert Stephenson whilst Scott's painting was taking shape.[47] A series of dynamic intersections between vertical and horizontal mechanical elements frame the vista beyond the workshop. The four lines of telegraph wires and the iron chain and pulley, the steamer's funnel and the

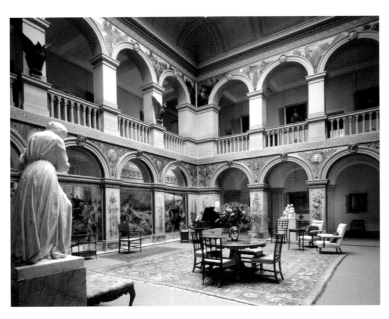

Iron and Coal, William Bell Scott, 1861 ©NTPL

Wallington Hall, Northumberland ©NTPL/Andreas von Einsiedel

cross beams of the ships' masts, all echo the graceful rise and span of Stephenson's High Level railway bridge, completed in 1849. These frames all soar over the gentlemen in stove piped hats, reminiscent of Brunel, on the quayside, negotiating the trade and transport which made Northumberland and Britain wealthy and vibrant. New ways of seeing and representing the world are suggested by the photographer in their midst, at work under his cloaked tripod just to the left of the pit boy's knee. Scott creates a symphony of different light and atmospheric effects. The divine shafts of natural light highlighting the workmen are juxtaposed with the man-made white heat of the furnace. The puffy clouds of smoke from the steamer funnel in the foreground, the locomotive crossing Stephenson's bridge and the chimneystack behind stand out against the natural wispy clouds of the north-eastern sky.

Nineteenth-century paintings of industrial labour, such as Scott's *Iron and Coal* and Ford Madox Brown's *Work* of 1852-63 portray this work as a largely masculine endeavour.[48] The First and Second World Wars not only greatly increased women's roles in industry, but also led to more artists representing these new contributions and experiences.[49] Within the newly established Imperial War Museum's remit to commission artists to represent the experiences of war, a 'Women's Work Sub-Committee' led by Lady Norman was founded to acquire artwork representing women's contribution to the war effort.[50] A newspaper article about this initiative highlights the contradictory responses that women encountered to their new roles. The article contrasts the suitably feminine nature of Lady Norman's looks, 'fragile in appearance, with grey eyes and quantities of soft brown hair and a delicate complexion' with her less conventional, masculine achievements: 'one of the comparatively few society women entitled to wear the coveted 1914 medal, for she ran a hospital in France during the first months of the war,' and 'an expert

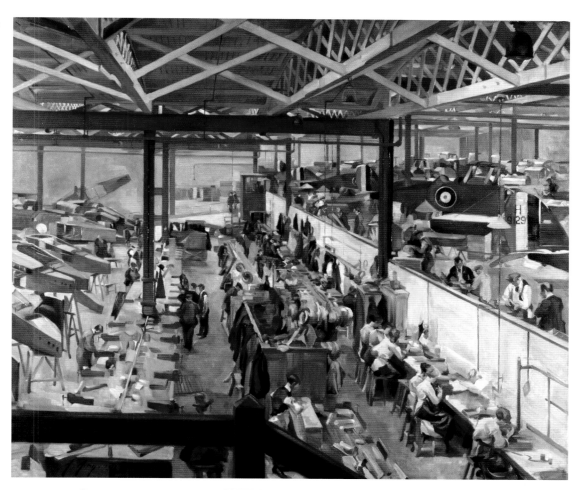

An Aircraft Assembly Shop, Hendon, Anna Airy, 1918

© Imperial War Museum

A Shell Forge at a National Projectile Factory, Hackney Marshes, Anna Airy, 1918

© Imperial War Museum

motorist, and driving her own car'.[51] A robust correspondence between Anna Airy (1882-1964), one of the handful of women who received painting commissions from the Imperial War Museum, and Mr A. Yockney signals the growing confidence of women in demanding rights equal to their male peers, culminating in gaining the vote in 1919. When asked to paint smaller canvases for less money than had been originally agreed in the official commission, Airy queried: 'You tell me that the whole scheme is revised and "several artists were asked to work in accordance with this new plan and agreed to do so"…were any of those artists definitely commissioned with myself to paint on the former arrangements?..were Messrs Orpen, Steer, Tonks, McEvoy and Nicholson suddenly told that their canvases and prices would be cut down and did they agree?'[52]

Women worked in dangerous conditions in munitions factories, often suffering from jaundice caused by expo-

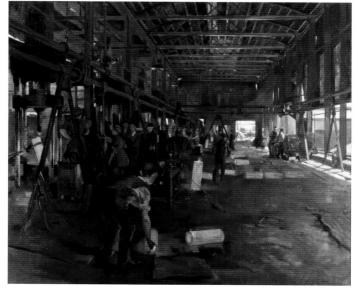

sure to toxic chemicals and maiming and burning when coming into contact with the metal shell casings. Anna Airy received commissions to paint a group of six large-

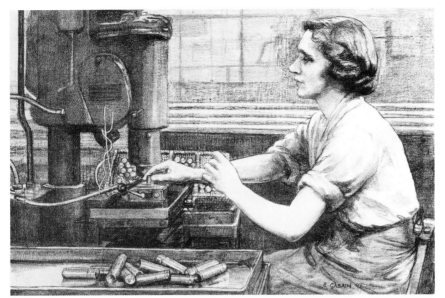

scale paintings representing women's work in munitions.[53] After the war, Anna Airy remembered the dramatic conditions in which she found herself painting:

> Much the most taxing job I had was painting the six-inch shells at Hackney Marshes. They'd bring them out in batches of twenty to forty at a time, and put them on the earth floor to cool. No matter where I stood, I'd have some rolled to within a few feet of me! I've never felt such heat!.. I burnt a pair of shoes right off my feet! I had to paint at lightning speed, for the metal which came out red-hot changed colour every minute as it cooled, and my oil paints dried as quickly as ink on writing paper! Usually, as I expect you know, they take about two days!.. At the Armstrong-Whitworth factory, where, to get the view I wanted, I had to work with my easel right across the rails that brought the 'castings' into the eighteen-inch gun jacket shop, I'd look round and find the engine driver had drawn up his great locomotive engine to within an inch of my shoulder blade, to see how I was getting on![54]

An Aircraft Assembly Shop, Hendon, 1918 portrays women at work most legibly, although one can just discern the pantaloons and caps of 'munitionettes' in the background of three others. In the erecting shop of an aircraft works, women appear seated in an orderly row on the right, stitching the canvas for the wings of the aircraft to be assembled in the upper hall where 'the stripes and circles of red white and blue denominating a British machine are painted on – together with the individual number of each machine.'[55]

It could be argued that women and children played an even greater part in the Second World War. Ethel Gabain (1882-1950) was commissioned by the War Artists Advisory Committee, part of the Ministry of Information and chaired by Sir Kenneth Clark, to create an album of lithographs portraying the experience of evacuee children, *Children in Wartime*. She was then asked to undertake a second album of six plates representing *Women's Work in the War*. Correspondence from EM O'Rourke Dickey in the Ministry of Information reveals the morale-boosting objective behind these albums. He explains that the artists had agreed to the low price for the prints to encourage 'the widest possible distribution [putting] more or less to one side any question of profit…since they regarded the making of them as a matter of national service.'[56] Indeed few of the albums appear to have sold initially, so Dickey distributed them directly to the organisations they depicted, for display.[57] Like Airy's reminiscences, Martin Hardie's recollections of Gabain's war series celebrated her intrepid journeys in search of her subjects: 'During the war, though hers was a thin spun life, she gallantly travelled all over the country under conditions of extreme discomfort, recording with unflinching zeal the work of women in factories, shipyards, canteens even in the lumber camps of the Scottish Highlands.'[58] *Tapping* subtly balances the potentially conflicting social roles of women who undertook industrial war work. Gabain shows this woman isolated in close up, a skilled worker at her machine, tapping cartridges. However, by choosing to show her in profile, Gabain also

reasserts her subject's womanliness, emphasising the delicate curl of her uncovered hair, the elegant curves of her body seen to advantage. The woman's posture and interaction with the munitions works machinery is reminiscent of work at a sewing machine, domesticating her industrial task. Her calm work is contrasted with the miniature scene in the red remarque, where a navy ship with pom-pom guns is under fire. Other plates in the album adopt a more distant viewpoint: tiny figures clamber over the massive shapes of tanks and 'Beaufort Fighter' aircraft. Even in these works, Gabain highlights the elegant slight frames of the women workers in chic overalls, lips sharply defined in lipstick, Pompadour hairstyles perfectly in place. The portfolio notes underline the grace of both machines, makers and flyers, renaming them 'Beaufighters'.[59]

This domesticating of industrial war work was not uniquely a feature of women entering the workplace. In his Oratory of All Souls at Burghclere in Berkshire, Stanley Spencer (1891-1959) had celebrated the humble tasks of military hospital orderlies with equal grandeur to the heroism of the front line.[60] This ensemble and his war artist commission for a painting of the Near Eastern sector of fighting in the First World War made him a natural choice for a commission during the Second World War.[61] In his commission for the War Artists Advisory Committee, Spencer represented the merchant shipyards of Port Glasgow as a space of intimacy, curiously reminiscent of his core motif of his home village of Cookham-on-Thames. He found a similar sense of belonging with the shipbuilding community in Port Glasgow:

> Men and people generally make a kind of 'home' for themselves wherever they are and whatever their work which enables the important human elements to reach into and pervade in the form of mysterious atmospheres of a personal kind the most ordinary procedures of work or place. Many of the rooms and corners of Lithgow's factory moved me in much the same way as I was by the rooms of my childhood.[62]

Lithgow's was a hive of activity throughout the war, fulfilling Ministry of War Transport commissions for eighty-four merchant ships, mostly 'Y-' or 'Empire-' class tramp steamers. Although these contracts attracted the horror of Luftwaffe bombing, it also brought work and a sense of pride in the war effort to this economically deprived region.[63] Spencer explored an impressive variety of industrial techniques and tasks in the ensemble, devoting panels to *Burners; The Template; Riggers; Riveters; Furnaces; Plumbers; Bending the Keel Plate* and *Welders*.[64] *Shipbuilding on the Clyde: Furnaces*, 1946 (*see* page 36) was the last panel of the vast ensemble of paintings that he completed; the full scheme was never realised. It was designed to be the central focus of the ensemble.

Carlyle's claims for the ennobling sanctity of manual work found new expression in Stanley Spencer's ensemble. The artist had resided with workers from the yard and gave many of his drawings away to them as tokens of friendship.[65] He was greatly distressed that the workers would be unable to see the exhibition of the completed works at the National Gallery in London and asked that the Lithgow's workforce might be sent photographs.[66] When these photographs did not prove forthcoming he wrote again: 'In view of the great interest they [the workforce] have shown and the degree to which they have collaborated with me I am sorry no reproductions that I know of have been sent to them.'[67] Throughout the ensemble, Spencer resolutely focused his attention on the sense of intimacy and transcendence of these skilled labourers. He captures the capacity of a human workforce to domesticate even the most harsh industrial surroundings: 'somehow they do, by their humanness, give to their immediate surroundings of angles, bars, structure, braces, corners and whatnot a homely touch. A ledge on which their teapot stands was never meant for it, yet seems more meant for that than its final purpose.'[68] However, Spencer did idealise the conditions in which his friendly 'collaborators' worked. A local man highlighted the unrealistic

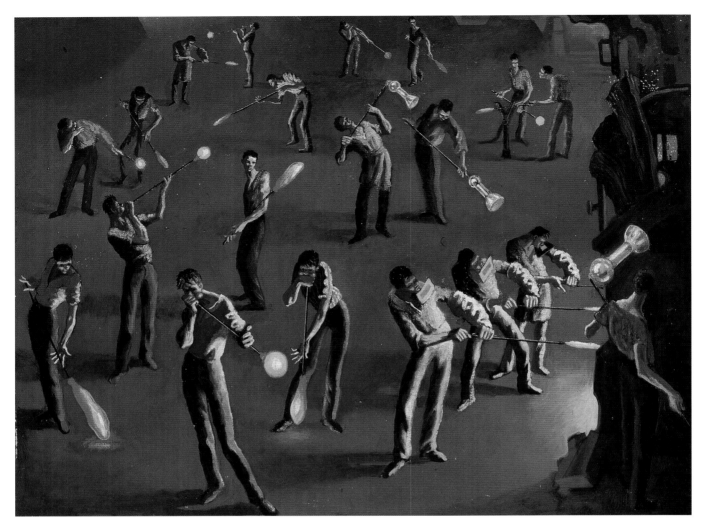

The Evolution of the Cathode Ray (Radiolocation) Tube, Mervyn Peake, 1943 ©Art Archive/Imperial War Museum

cleanliness of Spencer's representation: 'It was quite comical to us because all these shipyard workers down there had filthy jobs working down on these boats. They always wore caps and the caps were black, filthy black but he painted them as checks, glowing bright checks, red and yellow.'[69] However, this artistic licence should not be simply condemned as sanitising idealisation. Spencer, like his Victorian forebears William Bell Scott and Thomas Carlyle, endows the most physical and dirty manual labour with transcendent meaning:

> Not that I think that what I see them engaged on is what they are finally meant for, but that they are more like the angels in *Paradise Lost* who, though it is not their usual practice or occupation, had to hurl great pieces of rock at Satan's invading army. It is strange, but I think true, that where human activity is arranged and organised to some constructive end (such as shipbuilding) it will, through another avenue altogether, namely the spiritual framework of artistic desires, form another structure, a construction of designs and spiritual harmony.
> In art a parallel constructive order to that of the subject's utilitarian constructive purpose.[70]

Spencer and Gabain were not alone amongst the Second World War generation in recognising the transcendental relationships between industrial labour and art making. Mervyn Peake (1911-1968) petitioned the War Artists Advisory Committee for a commission to depict the contribution of the Rhondda miners to the war effort: 'I feel keyed up to do what I am sure will be the best and most significant work I have produced so far. The whole 'theme'

of the mines seems to be as thrilling a subject as I can imagine and I am eager to produce not only something important in the aesthetic field but to make a constructive contribution to the whole multi-sided war effort by showing what happens beneath the earth.'[71] In the end Henry Moore was commissioned to portray mining subjects, while Peake was invited to undertake a commission to portray 'the evolution of the radiolocation tube'. Peake travelled to Chance Brothers Ltd, a glass factory in Spon Lane, Smethwick, near Birmingham to observe the glass blowers at work. Chance's developed a new highly heat-resistant glass in the 1930s called 'Hysil' which was ideally suited to a request made by Baird's Television Company for specially blown cathode ray tubes. Although the development of television was put to one side with the outbreak of war in 1939, technicians developing radar soon recognised the usefulness of these tubes for their task. The limited call for cathode ray tubes meant that in 1939 Chance's had only one glassblower, called Deeley, who was able to blow these precision objects. Fourteen more men were taken on and by mid-1943 the firm produced 7,000 tubes per week for the Ministry of Aircraft production.[72]

Mervyn Peake was transfixed by the contrast between the sulphurous caverns in which this work was undertaken and the balletic grace of the glass blowers. He not only created an extraordinary suite of fifteen pastel sketches and two paintings of the glass blowers, but also wrote both an evocative short story and a poem inspired by them. Both texts liken the artistry of the glass blowers' manual labour to ballet, the poem perhaps most eloquently:

> It is the ballet of gold sweat. It is
> The hidden ballet of heavy feet
> And flickering hands: the dance of men unconscious
> Of dancing and the golden wizardries.
> Rough clothed, rough headed, drenched in sweat, they are
> As poised as floodlit acrobats in air,
> They twist throbbing fire-globes over water
> And whirl the ripe chameleon pears, whose fire

LOCOMOTION IN MAN 171

is no doubt about the decision. Fig. 111, for instance, shows that a man in running assumes at certain moments positions exactly like those represented in the old masterpieces.*

FIG. 111.—Instantaneous photograph of a runner: the position of the legs is the same as that of the man on the extreme left of the foregoing illustration.

It is quite easy to prove that runners never appear in the positions adopted by certain modern artists,

* One sometimes sees on a Greek vase a group of runners in the most curious positions. It is a perfectly familiar fact that a man in running or walking always swings the corresponding arms and legs in opposite directions. The corresponding arm and leg move, so to speak, in diagonal association. Now, on the Greek vase the arm and leg belonging to the same side are represented as moving in the same directions. Now, was this style of running, which is somewhat suggestive of the ambling of quadrupeds, really practised on the ancient race-course? or is it a mistake on the part of the decorator of the vase? This is a question we are unable to answer. Such a style of running is quite different from that now practised; yet at the same time it does not appear physiologically impossible. It is certainly a question worth considering.

> Threatens to loll like a breast, or a tongue or a serpent,
> Over the breath-rod and the surly trough.[73]

Peake's *The Evolution of the Cathode Ray (Radiolocation) Tube*, 1943 juxtaposes the extraordinary variety of postures and gestures deployed by these skilled industrial craftsmen in the creation of each tube. Like the pioneering photographer Etienne Marey, Peake arrests the different stages of movement in the process, recognising how easily a stage is lost to the naked eye in the speed of execution.[74] Peake seems to have been particularly struck by the contrast between the roughness of the men's external appearance and their unconscious internal balance and grace whilst twirling and breathing the fiery orbs into shape. In both workman and glass, brute matter is transfigured into beauty and grace.

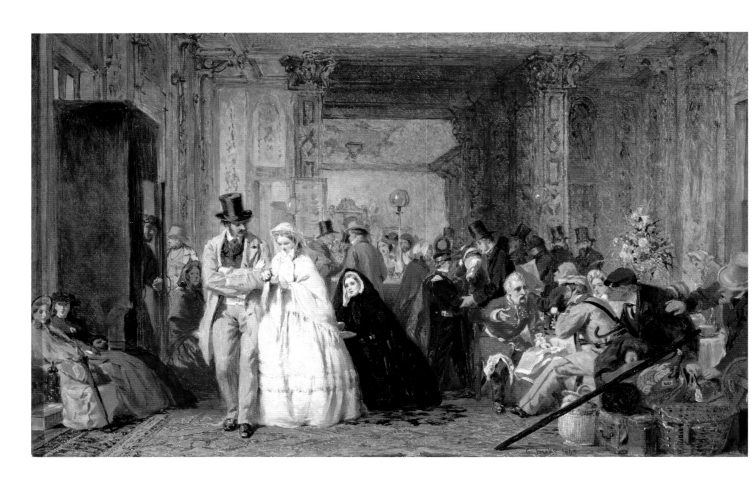

Swindon Station, George Elgar Hicks, 1863
Private collection

Marc Isambard Brunel, Pierre Jean David D'Angers, 1828
© National Portrait Gallery, London

Brunel as Artistic Engineer

Brunel's achievement as an engineer and inventor is all the more impressive because it was expressed through imaginative forms. The sleek profile of the ss *Great Britain*, the historic charm of Bristol Temple Meads station and the solid grace of the Clifton Suspension Bridge make these engineering innovations beautiful as well as useful. Brunel was a talented draughtsman, a collector of contemporary art, a friend of composers and poets. His inventiveness came from this creative balance of scientific, industrial knowledge and artfulness, an inspiring example for Brunels of the future.

The popular iconography of the nineteenth-century engineer, from Lucas's choice to paint his portrait of civil engineers in a site-hut to Howlett's famous photographs of Brunel, suggest a certain brash ruggedness. However, Brunel grew up in a cultured environment; a world traveller as well as an eminent engineer in his own right, his father Marc Brunel was eager for his son to have a well-rounded education. A glance at Brunel's taste in the decoration of his private home and his public works reveals a man of aesthetic awareness. His home life was

full of art and music; his marriage to Mary Elizabeth Horsley (1813-81) immersed him in a lively musical and artistic circle which included Félix Mendelssohn as well as two Royal Academicians, his wife's great uncle Sir Augustus Wall Callcott (1779-1844) and her brother John Callcott Horsley (1807-1903) who painted several portraits of Brunel and was a close friend. [75]

Both Brunel's plans for an Italian villa house at Watcombe in Devon and the inventories of his possessions in his Duke Street household reveal a man of opulent tastes in domestic interior decoration, including a large and varied collection of fine glass, china and silver services, Indian carpets and carved furniture.[76] Interestingly Brunel's main act as a patron of the arts was to commission a series of paintings from contemporary artists rather than to collect art of the past. In 1848, he wanted to create a 'Shakespeare Room' in the enlarged and refurbished Duke Street house.[77] Brunel planned every detail of the decoration and hang of the paintings, down to the graining of the plaster walls to look like oak, the selection of red velvet curtains and Venetian mirrors.[78]

Brunel's passion for Shakespeare paintings reflected a wider fashion for subjects inspired by great British authors. Boydell's 1786 Shakespeare Gallery had fuelled this taste which led to 1,400 Shakespearean-inspired paintings being exhibited in the Royal Academy of Arts in London between 1769 and 1900, with approximately twenty each year at mid-century.[79] He settled on Charles West Cope, Augustus Leopold Egg, Sir Edwin Landseer, Frederick Richard Lee, Charles Robert Leslie and Clarkson Stanfield to paint the works.[80] A letter to Sir Edwin Landseer says a lot about Brunel's attitudes to art and individual creativity: 'the choice of subjects I leave to the artist limiting only to selections from the *Acted* and *popular* plays of

Mrs Kean as Hermione, Charles R Leslie, 1848-9
© Royal Shakespeare Company

Scene from the Midsummer-Night's Dream, 1848-9
Sir Edwin Landseer
© National Gallery of Victoria, Melbourne, Australia

Macbeth, William Clarkson Stanfield, 1848-9
© Leicester City Museums Service

Launce's Substitute for Proteus' Dog,
Augustus Leopold Egg,1848-9
© Leicester City Museums Service

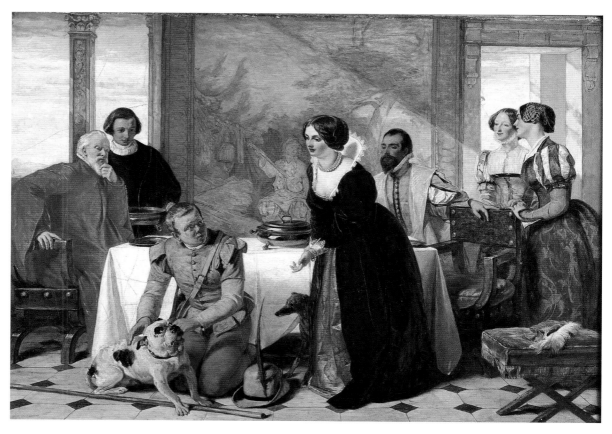

47

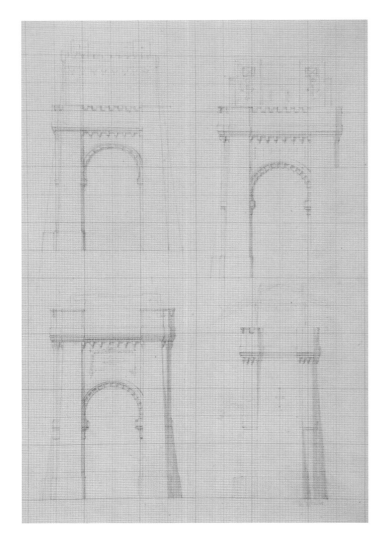

Sketch for bridge piers, IK Brunel, 1835 ©University of Bristol

Sketch for Shakepeare Room, IK Brunel, c.1848 ©University of Bristol

the *Author*'. He hoped that 'in choice of subject and in treatment each artist would endeavour to record his own peculiar style and produce as it were a characteristic picture of himself.'[81]

Brunel showed an impressive knowledge of ornamental styles in his architectural projects. His sketchbooks for the Clifton Suspension Bridge show a delightful freedom of experimentation. The piers are variously dressed as medieval castles, Moorish palaces and Egyptian temples.[82] On 28 March 1831, Brunel happily reports that 'the Egyptian thing I brought down was unanimously adopted'. The ruins at Tentyra inspired his design which included lotus motifs and figural friezes portraying the evolution of the bridge from a dream of the wine merchant William Vick, through to the building tasks of miners, metal workers, masons and carpenters. Samuel Jackson's watercolour shows the earliest incarnation of the Egyptian decoration; Brunel soon reversed the direction of the Sphinxes so their faces greeted those starting to cross the bridge.

Brunel's inspired choice of monumental Egyptian forms demonstrates his knowledge of archaeology as well as fashionable design and popular entertainment. Josiah Wedgewood had capitalised on the craze for Egyptian decoration, creating a set of black basalt ware in the 1770s. Napoleon's lavish biscuit porcelain Egyptian Services made by the Manufactures at Sèvres might have been a more immediate precedent. In 1818, Louis XVIII gave one of the services to the Duke of Wellington, ambassador to France, who had assisted the king's restoration.[83] Napoleon's conquest of Egypt had been an intellectual as well as military campaign. Domnique-Vivant Denon (1747-1825) was one of 167 scholars brought to document the antiquities. His two encyclopaedic publications *Voyage dans la Basse et la Haute Egypte Pendant les Campagnes du Général Bonaparte* (1819) and *Description de l'Egypte* published in 20 volumes between 1809 and 1828 became a vital resource for artists, architects and engineers. Denon's volumes were followed by many others, such as

48

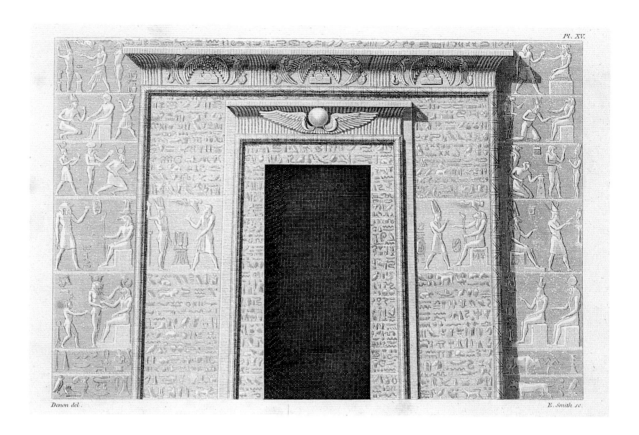

Tentyra, *Voyage dans
la Basse et la Haute
Egypte Pendant les
Campagnes du
Général Bonaparte*,
Domnique-Vivant
Denon, 1819

©University of Bristol

*Approved Design for
Clifton Suspension
Bridge* (detail),
Samuel Jackson, 1831

©Bristol's Museums,
Galleries and Archives

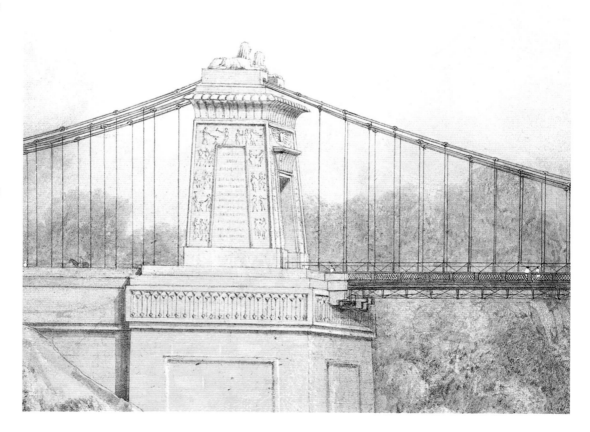

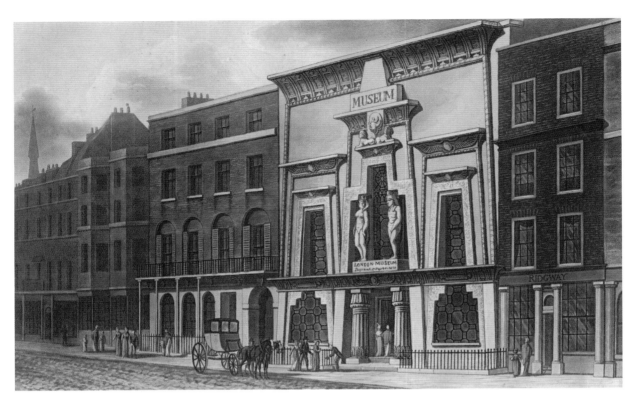

William Bullock's Egyptian Hall, 1812 ©Bill Douglas Centre, University of Exeter

Owen Jones's Egyptian Court at the rebuilt Crystal Palace in Sydenham, 1855 ©Science Museum Library/Science and Society Picture Library

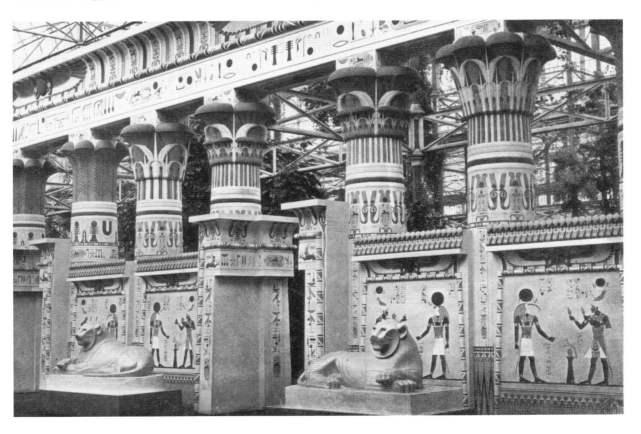

View of exterior of
Bristol Temple
Meads
©Clevedon Court
(National Trust)

Brunel on the
ss *Great Eastern*,
Robert Howlett,
1857
©National Portrait
Gallery, London

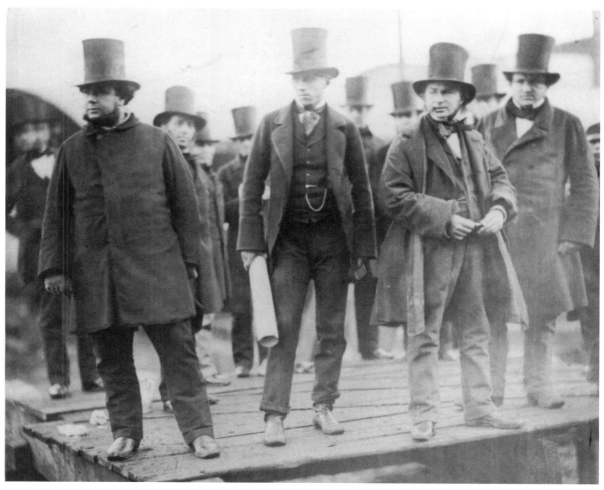

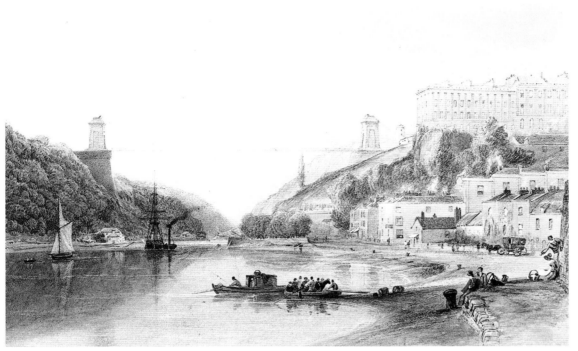

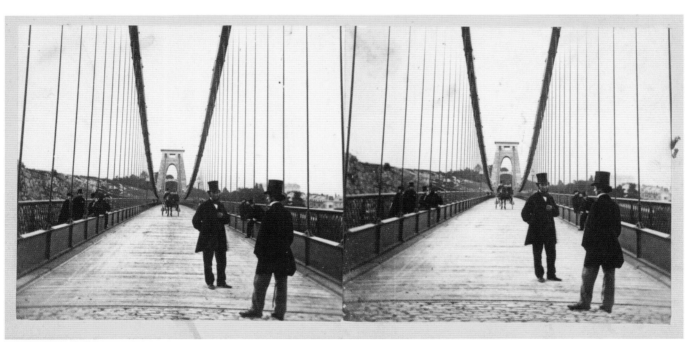

David Roberts's lithographic albums and Owen Jones's *Grammar of Ornament* of 1856.[84] These pattern books helped architects to adopt Egyptian architecture and decoration for numerous popular educational and entertainment venues. William Bullock's Egyptian Hall, built in 1812, was designed by Peter Frederick Robinson from a Denon illustration. The façade is an elaborate compendium of Egyptian motifs, the deities Isis and Osiris, sphinxes, a winged scarab, all surmounted by a cavetto cornice. The interior, decorated by J B Papworth in 1819, was equally lavish. The Egyptian Hall, and the exhibitions it displayed of Belzoni's finds as well as reconstructions of the Tomb of Seti I and the temples at Abu Simbel, spawned countless other delightful sites, such as the Egyptian House on

Chapel Street in Penzance of 1835 and Owen Jones's
Egyptian Court in the 1855 rebuilt Crystal Palace in Syden-
ham, all predecessors to the picture palaces of the 1930s.

Although Brunel chose Egyptian grandeur[85] for the
Clifton Suspension Bridge and Tudorbethan elegance for
Bristol Temple Meads, he was also happy to embrace the
stark modernity of iron and steel for Paddington Station.
George Elgar Hicks's (1824-1914) *Swindon Station* 1863
(*see* page 44) is a wonderful document of the plush con-
temporary décor of the Great Western Railway's
refreshment rooms.[86] Swindon station was composed of
two platform islands joined by an enclosed footbridge; the
ground floor of the two-storey block on each island was a
refreshment room, as JC Bourne describes: 'These rooms
occupy, one on each side, the whole floor: the decorations
on the walls and ceiling are Arabesque, and the columns
are painted after a recent invention to resemble inlaid
woods; each room is divided into two parts by columns
and an oval counter, at which the refreshments are sold,
and which separates the First-class passengers at one end
from the Second-class at the other.'[87] These elegant sur-
roundings were not matched by the quality of the
refreshments themselves. LTC Rolt laments: 'It was at Swin-
don Station that the railway refreshment room first
acquired the unsavoury reputation which it has never since
succeeded in living down', and then cites a letter from
Brunel to SY Griffiths, the refreshment room proprietor at
Swindon Station, about his coffee:

> Dear Sir,
>
> I assure you, Mr Player was wrong in supposing that I
> thought you purchased inferior coffee. I thought I said to
> him I was surprised that you should buy such bad
> roasted corn. I did not believe you had such a thing as
> coffee in the place; I am certain I never tasted any. I have
> long ceased to make complaints at Swindon. I avoid
> taking anything there when I can help it.
> Yours faithfully,
> I.K.Brunel [88]

IK Brunel, marble statuette Private Collection

Brunel's acerbic wit offers a good note upon which to end; it bespeaks his demand from all around him for excellence and tireless energy. The inventive age in which he lived offers inspiring precedents for the creative partnerships of art, industry and science we should strive to achieve. A backhanded compliment to the Victorians from J M Barrie, author of an Edwardian take on the adventures of travel, *Peter Pan in Kensington Gardens*, will serve as a final provocation for the Brunels of the future: 'Do not fail to speak scornfully of the Victorian Age. There will be a time for meekness when you try to better it.'

Notes

[1] *Self-Help* was followed by *Character* 1871, *Thrift* 1875, *Duty* 1880.

[2] The (in)famous Bloomsbury critique of Brunel's age, Lytton Strachey's *Eminent Victorians: Cardinal Manning, Florence Nightingale, Dr Arnold, General Gordon*, 1918, has often been seen as a young man's hubris knocking his worthy forbears from their pedestals. However, Strachey's approach to exploring cultural heroes transformed the nature of biographical writing, from sanitised myth into involving cultural history. One can admire and learn from exemplary figures like Brunel, recognising their flaws as well as their virtues. Similarly the incompatibility of heroic narratives like Smiles's with the realities of labour and capital in the nineteenth century, let alone in the twenty-first century, must be acknowledged, as Klingender succinctly argues: 'There was no possible means of reconciling these two points of view. Each was the expression of material conditions from which neither party could escape. The ideology of self-help alone could fit the capitalists for the ruthless competition they had to face. The need for independent solidarity was the bitter lesson the workers learned in the factory, where each was at the mercy of his masters unless all acted together.' Francis D. Klingender, *Art and the Industrial Revolution*, London: Evelyn, Adams and MacKay, 1968, p.171.

[3] This statue is the last of four major public monuments erected in the late Victorian period in central Bristol, the others are James Havard Thomas *Morley* 1887, Sir Joseph Edgar Boehm *Queen Victoria* 1888 and also by Thomas *Edmund Burke* 1894. See Douglas Merritt, *Sculpture in Bristol*, Bristol: Redcliffe Press, 2002.

[4] Colston's religious intolerance is equally problematic, as an 1872 *Handbook to Bristol and Clifton* remarked: 'His antipathy to dissent, it must be acknowledged, approaches the confines of bigotry.' Cited in Merritt, 2002, pp. 30-1. The attractive 'Liberty style' bas reliefs on the plinth emphasise Colston's generosity to the poor and his shipping trade, sanitised of its human 'cargo' of slaves, instead showing mermaids in a stormy sea and a dolphin reputed to have saved one of Colston's ships, which Colston took as his emblem. Swirling dolphins embellish the corners of the plinth.

[5] Cited in Tom Flynn, *The Body in Sculpture*, London: Weidenfield and Nicholson, 1998, p.160.

[6] The rediscovery of Albert Challen's 1869 portrait of Mary Seacole is resonant with the task of recuperating lost heroes. The painting had been used as a backboard to frame a print and was discovered by a dealer who had purchased the print in a car boot sale. Sold at auction to another dealer, the painting was identified as Seacole and has been lent to the National Gallery by the historian who now owns the work.

[7] The event was not a financial success, resulting in £233 for Seacole. An 1867 initiative led by Queen Victoria was more effective. In addition to two recent reprints of Seacole's autobiography, a flurry of useful popular biographies about Mary Seacole have been published in recent years including Emma Lynch, *The Life of Mary Seacole*, Oxford: Heinemann Library, 2005; Ron Ramdin, *Mary Seacole*, London: Haus, 2005 and Jane Robinson, *Mary Seacole The charismatic Black nurse who became a hero of the Crimea*, London: Constable, 2005. Mary Seacole was also a key figure in the recent Birmingham City Art Gallery exhibition recorded in Jan Marsh (ed.) *Black Victorians: Black People in British Art 1800-1900*, Aldershot: Lund Humphries, 2005.

[8] Preface to Alexander, Z. & Dewjee, A. (eds.), *Wonderful adventures of Mrs. Seacole in many lands*. Bristol: Falling Wall Press, 1984.

[9] Regrettably the painting was not available for inclusion in the exhibition.

[10] Lionel Lambourne, *An Introduction to Victorian Genre Painting*, London: HMSO, 1982, p. 19.

[11] John Wolffe, 'Anthony Ashley-Cooper,' *Oxford Dictionary of National Biography*, Oxford: Oxford University Press, 2004, pp.223-6 (hereafter referred to as the DNB).

[12] Kingsley Martin, *The Triumph of Lord Palmerston*, 1963 cited in Christopher Wood, *Victorian Panorama: Paintings of Victorian Life*, London: Faber and Faber Ltd., 1976, p.19.

[13] See Kate Colquhoun, *A thing in disguise: the visionary life of Joseph Paxton*, London: Fourth Estate, 2003.

[14] R A Buchanan has documented the Institution of Civil Engineers and other professional bodies such as the Institution of Mechanical Engineers founded in 1848 in R A Buchanan, *The Engineers: A History of the Engineering Profession in Britain 1750-1914*, London: Jessica Kingsley, 1989 and *Brunel: The Life and Times of Isambard Kingdom Brunel*, London: Hambledon, 2002.

[15] However, like so many inventors, Bessemer received no financial reward for his brilliantly un-patented solution. A succinct introduction to Henry Bessemer is provided by Geoffrey Tweedale's entry in *DNB*, 2004, pp.514-7.

[16] Regrettably the hospital was installed in the final days of the conflict and therefore had little impact, but it did provide an important prototype for future projects of this kind, Buchanan, 2002, pp.179-180.

[17] Wrought and cast iron was not strong enough to withstand the force of heavy artillery shells; steel, still essentially hand-produced material, was prohibitively expensive.

[18] John Ruskin in *Fors Clavigera* 1877 criticised the painting as a 'pot of paint flung in the face of the public'; the most authoritative account of the ensuing libel case is Linda Merrill, *A pot of paint: aesthetics on trial in Whistler v Ruskin*, Washington/London: Smithsonian Institution Press, 1992.

[19] Sir Matthew Digby Wyatt, the architect who collaborated with Brunel on the Great Western Hotel at Paddington, also collaborated on Jones's encyclopaedic illustrated study of decorative traditions from tribal Africa and ancient Egypt to medieval and Renaissance styles.

[20] These firms included Chubb & Co., Coalbrookdale Ironworks, Hukin & Heath, Elkington & Co., James Dixon & Sons and Benham & Froud, Minton & Co., Wedgwood, Linthorpe Art Pottery, William Ault of Swadlincote, Watcombe, Torquay and Old Hall Pottery, James Couper and Sons of Glasgow amongst many others. See Michael Whiteway (ed.), *Christopher Dresser: A Design Revolution*, London: V & A Publications, 2004.

[21] There is a vast literature on Victorian debates about poverty and work. A few key texts are P.D. Anthony, *John Ruskin's Labour: A Study of Ruskin's Social Theory*, Cambridge: Cambridge University Press, 1983; Peter Stansky, *Redesigning the World: William Morris, the 1880s, and the Arts and Crafts*, London, 1985. A forthcoming study will no doubt make another important contribution, Tim Barringer *Men at work: Art and Labour in Victorian Britain*, New Haven/London: Yale University Press, 2005. Dickens's description of Coketown in

Hard Times offers a stark sense of the bleakness of life in nine-teenth-century industrial towns:

Coketown, to which Messrs Bounderby and Gradgrind now walked, was a triumph of fact; it had no greater taint of fancy in it than Mrs Gradgrind herself. Let us strike the key-note, Coketown, before pursuing our tune. It was a town of red brick, or of brick that would have been red if the smoke and ashes had allowed it; but as matters stood, it was a town of unnatural red and black like the painted face of a savage. It was a town of machinery and tall chimneys, out of which interminable serpents of smoke trailed themselves for ever and ever, and never got uncoiled. It had a black canal in it, and a river that ran purple with ill-smelling dye, and vast piles of building full of windows where there was a rattling and a trembling all day long, and where the piston of the steam-engine worked monotonously up and down, like the head of an elephant in a state of melancholy madness. It contained several large streets all very like one another, and many small streets still more like one another, inhabited by people equally like one another, who all went in and out at the same hours, with the same sound upon the same pavements, to do the same work, and to whom every day was the same as yesterday and tomorrow, and every year the counter-part of the last and the next. These attributes of Coketown were in the main inseparable from the work by which it was sustained; against them were to be set off, comforts of life which found their way all over the world, and elegancies of life which made, we will not ask how much of the fine lady, who could scarcely bear to hear the place mentioned. The rest of its features were voluntary, and they were these. You saw nothing in Coketown but what was severely workful. If the members of a religious persuasion built a chapel there – as the members of eighteen religious persuasions had done – they made it a pious warehouse of red brick, with sometimes (but this is only in highly ornamented examples) a bell in a birdcage on the top of it. The solitary exception was the New Church; a stuccoed edifice with a square steeple over the door, terminating in four short pinnacles like florid wooden legs. All the public inscriptions in the town were painted alike, in severe characters of black and white. The jail might have been the infirmary, the infirmary might have been the jail, the town-hall might have been either, or both, or anything else, for anything that appeared to the contrary in the graces of their construction. Fact, fact, fact, everywhere in the material aspect of the town; fact, fact, fact, everywhere in the immaterial. The M'Choakumchild school was all fact, and the school of design was all fact, and the relations between master and man were all fact, and everything was fact between the lying-in hospital and the cemetery, and what you couldn't state in figures, or show to be purchasable in the cheapest market and saleable in the dearest, was not, and never should be, world without end, Amen. A town so sacred to fact, and so triumphant in its assertion, of course got on well? Why no, not quite well. No? Dear me!

[22] The most exemplary sources on this issue are Mary Cowling, *The Artist as Anthropologist: The Representation of Type and Character in Victorian Art*, Cambridge, 1989, Shearer West, *The Victorians and Race*, Aldershot, 1996, David Bate 'Train Up a Child in the Way He Should Go', *Third Text*, no.10, Spring 1990, pp. 53-9; C Herbert, 'Rat worship and Taboo in Mayhew's London', *Representations* 23, 1988; A Humphreys, *Travels into Poor Man's Country: The Work of Henry Mayhew*, Georgia, 1977.

[23] Klingender, 1968, pp.167-9. Klingender highlights Mrs Gaskell's shifting attitudes to trade unionism between the two novels; summarily condemned in the earlier novel, the representation of unions in *North and South* is more complex.

[24] Wood, 1976, pp.52-3.

[25] 'As the sails rose to the wind, and the ship began to move, there broke from all the boats three resounding cheers, which those on board took up, and echoed back, and which were echoed and re-echoed. My heart burst out when I heard the sound, and beheld the waving of the hats and handkerchiefs.' Chapter 57, 'The Emigrants' Charles Dickens's *David Copperfield*, first published in serialised parts between May 1849 and November 1850, illustrated by Phiz.

[26] I am indebted to John Westhorp as well as Richard Green and Matthew Green, Rachel Boyd, Roy Brindley and Peter Brady of the Richard Green Galleries for their help in researching this painting.

[27] *Daily News* 2 August 1887. The work was on exhibition in the Picture Gallery at the Crystal Palace at the time.

[28] This legislation came to be known as the 'Parliamentary Train Act' because of clause 11:

That the Companies may be required to provide upon such new Lines of Railway, as a **minimum** of third-class accommodation, one Train at least each way on every week-day, by which there shall be the ordinary obligation to convey such passengers as may present themselves at any of the ordinary stations, in carriages provided with seats and protected from the weather, at a speed not less than 12 miles an hour including stoppages, and at fares not exceeding a penny per mile; each passenger by such Train being allowed not exceeding 56 lbs. of luggage without extra charge, and extra luggage being charged by weight at a rate not exceeding the lowest charge by other Trains; Children under Three years being conveyed without extra charge; and children from Three to Twelve years at half-price.

It also stipulated rights of usage by the postal service, police and military and the regulation of profit margins, *see Parliamentary Papers*, 1844, XI, pp. 9-11.

[29] Solomon is reputed to have made studies of first-class compartments at Euston Station, Geffrye Museum exhibition catalogue, *Solomon – A Family of Painters*, London, 1985, p.51.

[30] Geffrye Museum, 1985, p.51 and Wood, 1976, p.214-5.

[31] The *Art Journal* reviewer identifies the scene as: 'A widow accompanying her child a sailor boy to Portsmouth or Southampton, whither he is proceeding by railway to join his ship, bound on a long voyage.' Both reviews cited in Geffrye Museum, 1985, p.52.

[32] Mary Cowling, *Victorian Figurative Painting: Domestic Life and the Contemporary Scene*, London: Andreas Papadakis, 2000, pp.89-90.

[33] The artist first painted this composition in 1858 (watercolour now in the Victoria and Albert Museum). This later version attests to the continued fascination with London's 'street arabs'. See Mark Bills, 'William Powell Frith's 'The crossing sweeper': an archetypal image of mid-nineteenth-century London', *The Burlington Magazine* May 2004, vol. CXLVI, no. 1214.

[34] Gradgrind's soullessness is most incisively captured in a scene where he denounces the little girl Sissy's 'fancy' for a flowered carpet:

'So you would carpet your room – or your husband's room, if you were a grown woman, and had a husband – with representations of flowers, would you?' said the gentleman. 'Why would you?'

'If you please, sir, I am very fond of flowers,' returned the girl. 'And is that why you would put tables and chairs upon them, and have people walking over them with heavy boots?'

'It wouldn't hurt them, sir. They wouldn't crush and wither, if you please, sir. They would be the pictures of what was very pretty and pleasant, and I would fancy — '

'Ay, ay, ay! But you mustn't fancy,' cried the gentleman, quite elated by coming so happily to his point. 'That's it! You are never to fancy.'

'You are not, Cecilia Jupe,' Thomas Gradgrind solemnly repeated, 'to do anything of that kind.'

'Fact, fact, fact!' said the gentleman. And 'Fact, fact, fact!' repeated Thomas Gradgrind.

'You are to be in all things regulated and governed,' said the gentleman, 'by fact. We hope to have, before long, a board of fact, composed of commissioners of fact, who will force the people to be a people of fact, and of nothing but fact. You must discard the word Fancy altogether. You have nothing to do with it. You are not to have, in any object of use or ornament, what would be a contradiction in fact. You don't walk upon flowers in fact; you cannot be allowed to walk upon flowers in carpets. You don't find that foreign birds and butterflies come and perch upon your crockery; you cannot be permitted to paint foreign birds and butterflies upon your crockery. You never meet with quadrupeds going up and down walls; you must not have quadrupeds represented upon walls. You must use,' said the gentleman, 'for all these purposes, combinations and modifications (in primary colours) of mathematical figures which are susceptible of proof and demonstration. This is the new discovery. This is fact. This is taste.'

[35] The terrible uses to which such theories of race and identity could be put are self-evident and have been the central focus of much Marxist and Post-Colonial scholarship of the last thirty years.

[36] Cowling, 2000, pp. 63-5.

[37] Cited in Cowling, 2000, p. 63.

[38] O'Neil's pair was one of many painterly responses to the 'Mutiny' such as Sir Joseph Noel Paton's *In Memoriam* 1858, Lord Lloyd Webber Collection.

[39] Wood, 1976, p.232.

[40] Thomas Gibson Bowles *Flotsam and Jetsam*, London 1882

cited in Nancy Marshall and Malcolm Warner, *James Tissot Victorian Life/Modern Love*, London: Yale University Press, 1999, p.81.

[41] Tissot's 1876 work *The Thames*, met with considerable criticism for the potential impropriety of its Royal Naval Reserve lounging with young ladies on a steam launch in the polluted waters of the Pool of London, see 'On shipboard' in Marshall and Warner, 1999, pp.81-95.

[42] Cited in Mary Chamot, Dennis Farr and Martin Butlin, *The Modern British Paintings, Drawings and Sculpture*, London: Tate Gallery, 1964, vol. II. This disruption took on deeper associations in the context of the First World War. Nevinson's new title *My Arrival in Dunkirk* for the 1915 London Group exhibition made the shattered forms and movement resonate with the chaos of the Western Front.

[43] 'There is a moral sentiment in the feeling for mechanics. The man who is intelligent, cold and calm has grown wings to himself…Society is filled with a violent desire for something it may achieve or may not. Everything lies in that: everything depends upon the efforts made and the attention paid to these alarming symptoms. Architecture or Revolution. Revolution can be avoided….[through] the mass production spirit. The spirit of constructing mass production houses. The spirit of living in mass production houses.' from *Towards an Architecture* 1923 (first published as articles in *L'Esprit Nouveau*) cited in Tim Benton et al., *Art Deco 1910-1939* London: V&A Publications, 2003.

[44] Thomas Carlyle, *Past and Present*, 1843 cited in Cowling, 2000, p.173.

[45] Klingender, 1968, p.155, Mary Cowling has discovered a fascinating relationship between the planning of *Iron and Coal* and Scott's reworking of a sketch by Thomas Sibson representing *Saxon Arts*, Cowling, 2000, pp.179-80.

[46] Tim Barringer, *Reading the Pre-Raphaelites*, London: Yale, pp.105-6.

[47] Paul Usherwood, 'W. B. Scott's *Iron and Coal*: northern readings' *Pre-Raphaelite Painters and Patrons in the North East*, 1989, p.47.

[48] Eyre Crowe's *The Dinner Hour, Wigan* of 1874, City of Manchester Art Galleries is a fascinating exception, a painting sadly unavailable for this exhibition.

[49] I am greatly indebted to Jenny Wood and Ulrike Schulte for drawing my attention to the works and the rich archival documentation which the Imperial War Museum holds on them.

[50] The Committee consisted of Lady Norman CBE as Chairman, Agnes Conway MBE as Honorary Secretary and Lady Askwith CBE, Mrs Carey Evans (née Lloyd George), Miss Durham CBE, The Honourable Lady Haig; Lady Mond and Miss Monkhouse MBE as members. Many leading male artists of the day were commissioned to portray women's contributions: the painters Stanhope Forbes, Sir John Lavery, William Nicholson, C R W Nevinson, William Rothenstein and William Orpen, and the sculptor Sir George Frampton. At least four women artists received commissions for paintings; many more were asked to create three-dimensional models representing women's war work from nursing to agriculture and factory work. Lists of works intended to be exhibited in the Royal Academy exhibition *Women's Work* held at Burlington Gardens in the autumn of 1919 are held in the Imperial War Museum Archives. One list indicates the following women as having submitted paintings: Lucy Kemp-Welch, Miss Clare Atwood, Miss Isabel Codrington. Another lists three-dimensional models created by Miss Foy, Lady Feodora Gleichen, Mrs Vereker Hamilton, Miss E Pyse, Miss Rock, Miss Winser, Mrs Gilbert Bayes, Mrs Meredith Williams, Mrs Wallace and Miss Rock. Another lists drawings received from Miss Phyllis Keyes, Miss Victoria Monkhouse, Miss Ursula Wood, Miss N E Issacs.

[51] Unidentified news clipping in the Imperial War Museum Archive.

[52] Letter dated 10 October 1918 from Airy to Mr Yockney, Imperial War Museum correspondence file. Mr Yockney's reply slightly obfuscates the question, indicating that McEvoy had already started his canvas and so could not change, and intimated that Orpen, Steer and Tonks had agreed to the new terms. His closing assertion that the smaller scale was 'especially preferable where Home themes are proposed' perhaps belies more gendered subtexts within these decisions.

[53] The first commission appears to date from May 1918 and was for a single painting of a munitions works. On 27 June 1918 the Imperial War Museum Committee gave Airy a second commission for four paintings on munitions subjects. A final

third commission was issued 4 March 1919 by the Women's Works Committee for a print version of *Women working in a Retort House*. One painting, *Munitions girls leaving work*, was refused by the Committee, seemingly due to a lack of finish (letter dated 28 May 1919 from A. Yockney). It was apparently destroyed by Airy (letters from Airy to Mr Yockney dated 30 May 1919 and 12 June 1919). The Imperial War Museum holds five paintings *Women Working in a Gas Retort House: South Metropolitan Gas Company*, London (2852); *A Shell Forge at a National Projectile Factory, Hackney Marshes* (4032); *An Aircraft Assembly Shop, Hendon* (1918); *Forging the Jacket for an 18 inch Gun at Messrs Armstrong Whitworth and Co.'s Works at Openshaw* (2272), (also as an etching 1989); *15 inch Shell Shop at Singer's Glasgow* (2271).

54 Anna Airy, 'My Adventures with Brush and Palette', *Pearson's Magazine*, October, 1924, Vol. LVIII, pp.294-5.

55 Airy's own description of the painting for the Commission, correspondence file Imperial War Museum Archives.

56 Document dated 9 December 1940 (ref GP/46/10) Imperial War Museum Archives. Another letter dated 21 December 1940 from the HMSO suggests that another price was proposed for American buyers 'to give the maximum profit'.

57 A letter dated 9 July 1942 from L Mackintosh of the Ministry of Labour and National Service Regional Office in Edinburgh thanks Dickey for the gift and its timeliness as the lithographs immediately became part of an information display at the Regional Office 'where we have girl trainees working on machines and displays by the Nursing, N.A.A.F.I., Land Army, A.T.S., etc. Services…The lithographs…are a very welcome addition to our pictorial display, and I am sure will be much appreciated by the Public visiting the Centre…I did not have the pleasure of meeting Miss Gabain when she was in Scotland, but I heard of her and am pleased to know she found my staff helpful.' Ref GP/46/10/2 Imperial War Museum Archives.

58 Martin Hardie Introduction in *Royal Society of British Artists* (exhibition catalogue), *Ethel Gabain (Mrs John Copley) RBA ROI*, London, 1950, p.4. Gabain, and her husband John Copley, had championed the revival of lithography as founder members of the Senefelder Club in 1910.

59 'No new type of aircraft has been more successful than the "Beaufighter". Our superb airmen deserve the best machines and these girl workers are determined they shall have them.' Cited in the Imperial War Museum Art Catalogue entry for LD 1536.

60 The chapel was commissioned by the Behrend family in honour of Mrs Behrend's brother who had served in Macedonia during the First World War, only to die of an illness contracted whilst there. For a full account of the project see the forthcoming study, Paul Gough, *Stanley Spencer: Journey to Burghclere*, Bristol: Sansom & Company, 2006.

61 Initially the War Artists Advisory Committee asked for a single painting of a shipyard for a sum of £50. However, Spencer was deeply inspired by his visit to Lithgow's Kingston Yard at Port Glasgow and began conceiving a vast ensemble of friezes representing thirteen different skills required in constructing a ship. Lacking funds to commission the entire ensemble, the Committee increased his commission to £300 to allow him to complete the first five panels. The success of these first works meant Spencer was funded to work on the whole series throughout the war.

62 Letter from Spencer to Dickey 1 June 1940 Imperial War Museum GP/55/31 (A), cited in Andrew Patrizio and Frank Little, *Canvassing the Clyde: Stanley Spencer and the Shipyards*, Glasgow: Glasgow Museums 1994, unnumbered pages, note 5.

63 Port Glasgow had suffered deep economic depression in the 1930s, with eleven out of twelve men out of work in 1931, See Patrizio and Little, 1994.

64 Seven of these eight panels take the form of long narrow friezes. Four are composed in three parts, i.e. two rectangular panels with a central upright panel in the middle. Although the height of the rectangular side panels is consistent throughout, the lengths vary considerably. In the *Burners* triptych, for example, the two side rectangular panels measure 50.8 x 293.2 cm (LD 432) and 50.8 x 203.2 (LD 434); the central upright measures 106.7 x 153.4 cm (LD433). *The Welders*, however, is symmetrical (two rectangular side panels both measure 50.7 x 203.2 cm LD 924 and LD 926).

65 'Nine of the best drawings I did of people I gave to the respective people themselves so that I only have five of the fourteen portraits I did.' Letter from Spencer to Moodie dated 6 October 1943 Imperial War Museum Archives GP/55/31(A); for dates and names of his hosts see Patrizio and Little, 1994. In his Oratory of All Souls at Burghclere in Berkshire, Spencer had

celebrated the humble tasks of military hospital orderlies with equal grandeur to the heroism of the front line.

66 'The workers are very disappointed not to be able to see the paintings themselves. Would it not be possible to send them photos of the ones I have done?' Letter from Spencer to Dickey dated April 1941 Imperial War Museum Archives GP/55/31 (A). A newspaper article also reinforced this sense of friendship and collaboration: 'The artist stayed in the cottage of a Clyde-side craftsman while he was gathering his impressions of the shipyard. He tells me the men called him their mascot – a reference not only to his small size but to the intense interest he showed in what they were doing', 'Pocket Full of Pictures' *Daily Telegraph*, 11 October 1941.

67 A letter from Spencer to Palmer 7 October 1943 Imperial War Museum Archives GP/55/31 (B).

68 A letter from Spencer n.d. Imperial War Museum Archives GP/55/31(A).

69 Interview with Roy Whiteford 4 October 1993 cited in Patrizio and Little, 1994.

70 A letter from Spencer September 1942 in Tate Gallery Archives 733/2/199, cited in Patrizio and Little, 1994.

71 A letter from Mervyn Peake, 15 April 1942 while stationed at Clitheroe, Lancashire in Imperial War Museum Archives.

72 For a detailed historical account of the history of this firm and the technicalities of their varied glass production since the eighteenth century, see Greville Watts, 'A Poet in the Glasshouse', *Glass Association Journal*, 1990, pp.41-5.

73 Peake's poem 'The Glassblowers' is cited in full in Watts, 1990, p.42.

74 Etienne Marey *Movement*, 1895 (first published in French in 1874).

75 See Rosamund Brunel Gotch, *Mendelssohn and His Friends in Kensington. Letters from Fanny and Sophy Horsley Written 1833-36*, London: Oxford University Press, 1934; and R Angus Buchanan, *Brunel The Life and Times of Isambard Kingdom Brunel*, London/New York: Hambledon and London, 2002, pp.17-18; 194-200.

76 Buchanan, 2002, p.194.

77 Hilarie Faberman and Philip McEvansoneya 'Isambard Kingdom Brunel's "Shakespeare Room"', *The Burlington Magazine*, Vol. 137, No. 1103, (Feb. 1995) pp.108-18.

78 I Brunel *The Life of Isambard Kingdom Brunel*, London, 1870, pp. 505-7, C B Noble *The Brunels Father and Son*, London, 1938, p.187 and Faberman and McEvansoneya, 1995, p. 110.

79 G Ashton, *Shakespeare's Heroines in the Nineteenth Century*, Buxton: Buxton Museum and Art Gallery, 1980, p. iv cited in Faberman and McEvansoneya, 1995, p. 108 who also highlight the 1843 mural decoration competition for the Houses of Parliament and the 1847 Robert Vernon gift of his modern British paintings collection to the nation as inspirations.

80 Faberman and McEvansoneya list the ten paintings as: Sir Augustus Wall Callcott and John Callcott Horsley *Launce Reproving his dog* 1849 (whereabouts unknown) which underlines the earlier point of the directness of Brunel's artistic sympathies with his family by marriage, painted by his wife's brother and uncle;

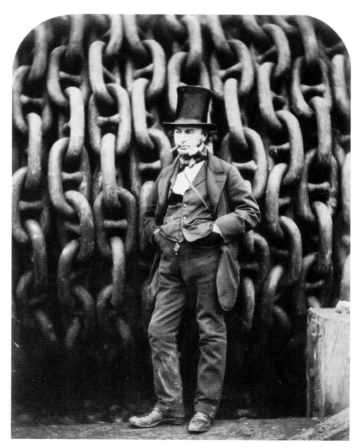

Brunel with chains, Robert Howlett
©National Portrait Gallery, London

Charles West Cope *King Lear Act IV, scene vii* 1848-50 (whereabouts unknown); Augustus Leopold Egg *Launce's substitute for Proteus' Dog Two Gentlemen of Verona Act IV*, scene iv 1849 (Leicester City Museums Service); John Callcott Horsley *Romeo and Juliet Act III, scene vii* (whereabouts unknown); Sir Edwin Landseer *Scene from the Midsummer-Night's Dream. Titania and Bottom; Fairies Attending – Peas-blossom, Cob-web, Mustard-seed, Moth, etc. A Midsummer Night's Dream Act III, scene I* (National Gallery of Victoria, Melbourne); Frederick Richard Lee *Jacques and the stag, As You Like It Act II, scene I* (whereabouts unknown); Charles Robert Leslie *Scene from Henry VIII Act I scene iv* (whereabouts unknown); Charles Robert Leslie *Scene from Henry VIII Queen Katherine of Aragon's Interview with Capucins, Henry VIII's Ambassador at Kimbolton Henry VIII Act IV scene ii* (Mead Art Museum, Amherst College, Amherst Massachusetts, Charles Robert Leslie Hermione *A Winter's Tale* Act V, scene iii (Royal Shakespeare Theatre Picture Gallery and Museum, Stratford-upon-Avon); Clarkson Stanfield *Macbeth Act I scene iii* (Leicester City Museums Service).

[81] The passages from this letter in the private collection of Nicholas Mackenzie are cited in Faberman and McEvansoneya, 1995, pp. 109-10.

[82] Francis Greenacre and Sheena Stoddard have documented the four projects in detail. Brunel initially chose a style for design no.1 which they describe as '…'Saxon Architecture' as most suited to the landscape. Nowadays the decorative detailing of the piers in design No.1 might be described as somewhat fanciful Romanesque.' They characterise design No. 2 as 'Gothic' and No. 3 as 'an elegant Gothic style based on Wren's gateway at Christ Church Oxford.' At one stage as a cost cutting measure, the Moorish design supplanted the selected Egyptian programme. Ultimately the bridge, erected after Brunel's death, was never decorated. Francis Greenacre and Sheena Stoddard, *The Bristol Landscape*, Bristol District Council, 1988, pp.48-53.

[83] Musée du Louvre, *Egyptomania: Egypt in Western Art 1730-1930*, Paris: Reunion des Musées Nationaux, 1994, p.235.

[84] David Roberts, *The Holy Land, Syria, Idumea, Egypt & Nubia/from drawings made on the spot by David Roberts, with historical descriptions by George Croly, lithographed by Louis Haghe*, vol.1-6, London: F G Moon, 1842-49. Many nineteenth-century painters, such as Sir Edward Poynter (1836-1919) and Jean Léon Gérôme (1824-1904), were particularly admired for

List of works in the exhibition

Anna Airy (1882-1964)
An Aircraft Assembly Shop, Hendon 1918
182.8 x 213.3 cm
Imperial War Museum, London

Isambard Kingdom Brunel (1806-1859)
Four sketchbooks: 31.8 x 40 x 17.5 cm
Special Collections University of Bristol Arts and Social Sciences Library

Isambard Kingdom Brunel's instrument box
Wood veneer (includes pens, bone rulers): 20 x 16.8 x 4.8 cm
Special Collections University of Bristol Arts and Social Sciences Library

Claude Buckle (1905-1973)
Bristol, Travel by Train 1952
Mechanical print process 101.9 x 63.4 cm
Bristol's City Museums and Art Gallery (K5895)

William Clarkson Stanfield (1793-1867)
Macbeth 1848-9
Oil on canvas: 80 x 132 cm
Leicester City Museums Service

Pierre Jean David D'Angers (1788-1856)
Marc Isambard Brunel 1828
Bronze Medal: 12.4 cm diameter
National Portrait Gallery London

Charles Robert Darwin (1809-1882)
The expression of the emotions in man and animals London: Murray, 1888
Illustrated Book: 26 x 20 x 80 cm
Special Collections University of Bristol Arts and Social Sciences Library

Charles Robert Darwin (1809-1882)
The movements and habits of climbing plants London: Murray, 1888
Illustrated Book: 25 x 19.5 x 9 cm
Special Collections University of Bristol Arts and Social Sciences Library

Baron Dominique-Vivant Denon (1747-1825)
Voyage dans la Basse et la Haute Egypte, London: C. Taylor, 1819
Illustrated Book: 51 x 68 x 4 cm
Special Collections University of Bristol Arts and Social Sciences Library

Christopher Dresser (1834-1904)
Hat Stand
Wrought iron: 190 x 65 x 22.3cm
Victoria and Albert Museum, London

Augustus Leopold Egg (1816-1863)
Launce's Substitute for Proteus' Dog 1848-9
Oil on canvas: 54.9 x 79.4 cm
Leicester City Museums Service

Sir Luke Fildes (1843-1927)
Applicants for Admission to Casual Ward 1874
Oil on canvas: 137.1 x 243.7 cm
Royal Holloway and Newham College, Egham Surrey

Tony Forbes (1964-)
Sold down the River 1999
150.5 x 120 cm
Bristol's City Museums and Art Gallery

William Powell Frith (1819-1909)
The Railway Station
Oil on canvas: 170.1 x 309.8 cm
Royal Holloway and Newham College, Egham Surrey

Ethel Gabain (1882-1950)
Tapping from the album *Women's Work in the War* c.1941-2
Lithograph: 45.7 x 68.5 cm
Imperial War Museum, London

Frederick Daniel Hardy (1826-1911)
Playing Doctors 1863
Oil on canvas: 75.5 x 91.5 cm
Victoria and Albert Museum, London

Hubert von Herkomer (1849-1914)
On Strike 1891
Oil on canvas: 228 x 126.4 cm
Royal Academy of Arts, London

George Elgar Hicks (1824-1914)
Swindon Station 1863
Oil on canvas: 20.3 x 30.5 cm
Private collection

Robert Howlett (died 1858)
Brunel with chains
Photograph: 28.6 x 22.5 cm
National Portrait Gallery, London

Robert Howlett (died 1858)
Brunel et al on Great Eastern
Photograph: 27.6 x 24.1 cm
National Portrait Gallery, London

Samuel Jackson (1794-1869)
Approved Design for Clifton Suspension Bridge 1831
Watercolour: 63.6 x 106 cm
Bristol's City Museums and Art Gallery

Samuel Jackson (1794-1869)
The proposed Suspension Bridge from Rownham Ferry 1836
Watercolour: 18.4 x 29 cm
Bristol's City Museums and Art Gallery

Owen Jones (1809-1874)
Grammar of Ornament 1856
Illustrated Book: 48 x 35 x 12 cm
Special Collections University of Bristol Arts and Social Sciences Library

Charles Robert Leslie (1794-1859)
Mrs Kean as Hermione 1848
Oil on canvas: 73.7 x 50.8 cm
Royal Shakespeare Company Collection

John Lucas (1807-1874)
Conference of Engineers at Britannia Bridge 1851-3
Oil on canvas: 163 x 215cm
Institution of Civil Engineers

Auguste Marie Louis Nicholas Lumière (1862-1954) and Louis Lumière (1864-1948)
A Train arriving at La Ciotat 1895
Silent film
British Film Institute

William Macduff (flourishing 1844-1876)
Shaftesbury or Lost and Found 1862
Oil on canvas: 47 x 47.6 cm
Museum of London

Étienne Jules Marey (1830-1904)
Movement (translated by Eric Pritchard) London: Heinemann, 1895
Book with photographic plates: 20 x 16 x 5 cm
Special Collections University of Bristol Arts and Social Sciences Library

Henry Mayhew (1812-1887)
London Labour and the London Poor 1851-62
Illustrated Book: 24 x 35 x 4.2 cm
Special Collections University of Bristol Arts and Social Sciences Library

Marie George Jean Méliès (1861-1938)
A Trip to the Moon 1902
Silent film
British Film Institute

Christopher Richard Wynne Nevinson (1889-1946)
The Arrival 1913
Oil on canvas: 76.2 x 63.5 cm
Tate London 2005

Henry Nelson O'Neil (1817-1880)
Eastward Ho! August 1857
Oil on canvas: 121 x 101 cm
Museum of London

Henry Nelson O'Neil (1817-1880)
Home Again 1858
Oil on canvas: 152 x 123 cm
Museum of London

Henry Nelson O'Neil (1817-1880)
The Parting Cheer 1861
Oil on canvas: 170.5 x 222.5 cm
National Maritime Museum London

Mervyn Peake (1911-1968)
The Evolution of the Cathode Ray (Radiolocation) Tube 1943
Oil on canvas: 85.1 x 110.5 cm
Imperial War Museum, London

Edwin Aaron Penley (flourishing 1860s)
Interior of Royal Yacht Victoria and Albert II; Dining Saloon 1864
Watercolour: 52.1 x 87.7 cm
Royal Collection

David Roberts (1796-1864)
The Holy Land, Syria, Idumea, Egypt & Nubia from drawings made on the spot by David Roberts, with historical descriptions by George Croly
Lithographed by Louis Haghe Vol 5
Illustrated Book: 87 x 62.5 x 28 cm
Special Collections University of Bristol Arts and Social Sciences Library

William Bell Scott (1811-1890)
Iron and Coal 1861
Watercolour: 38 x 35 cm
Victoria and Albert Museum, London

Abraham Solomon (1824-1862)
First Class – The Meeting 1855
Oil on canvas: 54.6 x 76.2 cm
Southampton City Art Gallery, Hampshire, UK

Abraham Solomon (1824-1862)
Second Class – The Parting 1855
Oil on canvas: 54.6 x 76.2 cm
Southampton City Art Gallery, Hampshire, UK

Stanley Spencer (1891-1959)
Shipbuilding on the Clyde: Furnaces 1946
Oil on canvas: 156.2 x 113.6 cm
Imperial War Museum, London

James Tissot (1836-1902)
Portsmouth Dockyard 1877
Oil on canvas: 38.1 x 54.6 cm
Tate Britain

W H Titcomb (1858-1930)
The Wealth of England: The Bessemer Convertor 1895
128 x 167 cm
Corus Engineering, with thanks to Sheffield Industrial Museums Trust

Frans Xavier Winterhalter (1805-1873)
The First of May 1851
Oil on canvas: 107 x 130 cm
Royal Collection

Brunel statuette
Marble: 46 x 20 x 20 cm
Private collection

Stone commemorating the start of works on Clifton Suspension Bridge
Old Red Sandstone: 25 x 26.5 x 9 cm
Bristol's City Museums and Art Gallery

View of Bristol passenger shed and exterior of Temple Meads
Lithograph: 45 x 35 cm
Clevedon Court (National Trust)

View of exterior of Temple Meads
Lithograph: 40 x 35 cm
Clevedon Court (National Trust)

Souvenir scarf of 1851 Crystal Palace Exhibition
Silk: 73 x 85 cm
Private collection

Thames Tunnel 'peep show'
Folded paper: 18 cm x 17 cm
Private collection

Stereoscopic Viewer
Wood and metal: 18 cm x 23 cm x l40 cm
Private collection

Stereoscopic Photograph
Private collection

Bristol Temple Meads sign
Enamelled steel: 86.5 in diameter
Bristol's City Museums and Art Gallery

Pegasus Engine
Machined Alloys
Rolls Royce Heritage Trust

1959 Austin Seven Mini 'Downtown'
Heritage Motor Centre

Ship's Clock
Bristol's City Museums and Art Gallery